STILL LIFE

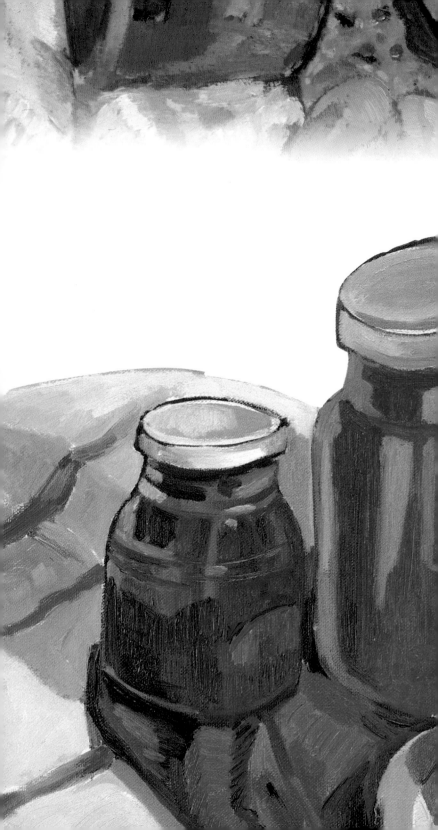

CONTENTS

PAINTING AND THE STILL LIFE

One of the most widely painted subjects is the still life. In fact, this theme is found
in all other genres, sometimes as just a complement and other times as a subject
in itself in which the painter has studied the light, form, and composition of the subject.
Since the baroque period the still life has become a cornerstone of all artistic studies.

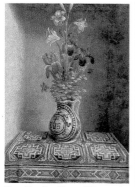

Hans Memling, Vase of Flowers in
an Alcove.

The First Still Life

Until Caravaggio used an
arrangement of objects as a
theme, the still life was merely
a complement of other pic-
torial motifs. Nonetheless, it
is relevant to note that one
century before Caravaggio, in
1470, a pupil of Roger van
Weiden used the reverse side
of a painted canvas to paint a
still life containing various
objects set in a niche. Later on,
in 1490, Hans Memeling also
painted a vase of flowers in an
alcove on the back of a canvas.

Caravaggio and the Still Life

The still life as a theme in
itself did not truly exist until
Caravaggio executed his in the
purest possible manner. Up
until that time, painters had
included small studies of objects
in their pictures, in order to lend
the scene atmosphere.

The principal reason for
Caravaggio's choosing the still
life as a subject was to prove his
virtuosity. For him the still life
represented a theme full of
textures, colors and, above all,
light.

Since then the still life theme
has become the art students'
most important tool for learn-
ing about and developing the
effects of light on objects and
the simulation of the third di-
mension.

Basket of Fruit *(1596). This
painting by Caravaggio is the first
still life in the history of art.*

Baroque Art and the Still Life

It was not long before
Caravaggio's personal work
became popular and the chiaro-
scuro technique he developed
was used in subjects dealing
with customs and manners,
such as tavern scenes, in which
poverty and simplicity were
depicted.

The astonishingly realistic
treatment given to the objects
had a decisive influence on
Velázquez's paintings, which
included the still life in
everyday scenes.

Velázquez, The Water Carrier
of Seville.

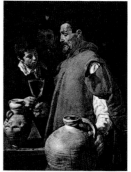

Velázquez, Old Woman Cooking
Eggs.

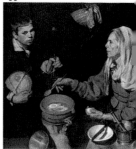

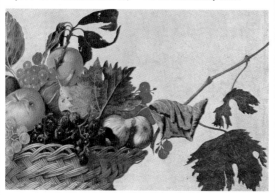

Learning from the Masters

Just like language, painting has to be learned by gradually discovering what others have already learned. Since the first still life was painted, this motif has undergone an enormous number of transformations before reaching the maturity we know today. The painter should regularly look at the works of the great masters of past and present in order to have a global perspective of the pictorial genre.

Esther Olivé, Still Life in Red. *Contemporary painting incorporates the legacy of previous styles; here the still life has been executed with a markedly fauvistic tendency.*

Vanities, Senses, and Symbols

By the beginning of the seventeenth century, three basic types of still life had been developed. One of them, known as vanities, was intended to be a reminder of the impermanence of life. The human skull, watches, and books were used as symbols of death.

Another seventeenth-century still life theme was symbolic in nature and tried to somehow represent the five senses by linking them to flowers, plates of food, fruit, metallic objects, etc.

This so-called symbolic still life reappeared much later on representing themes of human knowledge: the arts, the sciences, and letters.

The Contemporary Still Life

Throughout the different periods, art has adapted to the ideology and evolution of society, giving rise to different artistic styles.

Until the arrival of the avant-garde movement, painters did nothing more than try to capture a realistic representation of reality. But the Impressionists discovered a new way of painting the still life. Cézanne painted interpretations in a style that later, thanks to Picasso, would eventually develop into Cubism.

Nowadays the still life continues to be painted fairly assiduously by professional and amateur painters alike.

Cézanne, Still Life. *Cézanne's contribution to the development of contemporary art was definitive.*

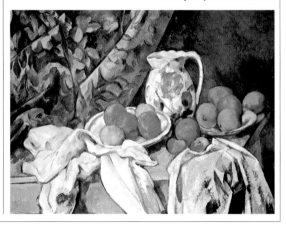

THE MEDIUM

PERSPECTIVE IN STILL LIFE

The still life's main lines are governed by the rules of perspective.
In other pictorial themes, perspective is often substituted by the superimposition
of planes to represent depth in the painting. The still life, on the other hand, is situated
so close to the spectator that the artist has to understand the rules of perspective
in order to paint a correct three-dimensional representation. We should also mention
at this stage that these rules only affect realistic paintings.

Types of Perspective

There are basically two kinds of perspective, depending on the position the object is viewed from. These two types of perspective, parallel perspective (when the object is seen from the front) and oblique perspective (when the object is seen from a three-quarters position) have been in use since the Renaissance.

There is no perspective in an object whose contour lines are completely parallel and do not converge at a single vanishing point. That is, we can only situate an object in perspective when the contour lines (vanishing lines) run parallel with one another and meet at a single point (parallel perspective) or when the object is situated in a three-quarter position, which makes the vanishing lines meet at two different points (oblique perspective).

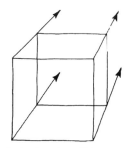

A cube drawn in parallel perspective.

A cube drawn in oblique perspective.

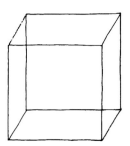

If the lines of depth do not converge at a single place on the horizon line, the object lacks perspective.

Parallel Perspective

With parallel perspective there is only one vanishing point and all the object's planes, except those that indicate depth, run in parallel and meet at a vanishing point on what we refer to as the horizon line.

This is the most simple type of perspective, since there is only one vanishing point to deal with.

In order to situate a simple object, such as a book, in perspective, we must first draw the frontal plane; this provides us with height and width. Now by situating an imaginary vanishing point on the *horizon line*, we must draw *vanishing lines* from each corner to the *vanishing point*. Within this scheme we can now draw

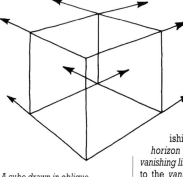

Example of how an object is drawn in parallel perspective.

a book or any other object.

It is essential that all the elements in a painting have the same perspective.

Oblique Perspective

Oblique perspective is characterized by having two different vanishing points that are independent of the point of view.

When the lines of an object form two sets of lines, each converging at the horizon but not parallel to each other, the object is drawn in oblique perspective.

MORE INFORMATION

• Composition and balance **p. 16**
• Dimensions and proportions **p. 24**
• Superimposing planes in a still life **p. 26**

Frameworks

To draw the elements of a still life in perspective, the painter should be aware of the rule of perspective. It is fairly easy to represent a simple element with a single vanishing point (parallel perspective); all you have to do is establish the horizon line and the vanishing point. The execution of a cube in perspective also allows you to learn how to resolve cylindrical forms within them.

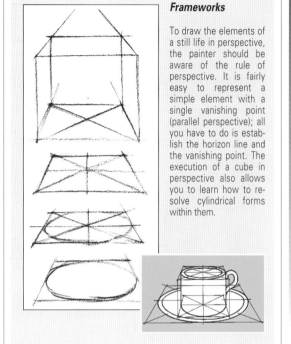

Oblique perspective tends to have a greater impact on the spectator than parallel perspective. Its two vanishing points mean that the model is devoid of any parallelism between the different planes.

THE SUBJECT

No matter what artistic tendency painters favor, whether it be academic or impressionist, they always base their work on a subject.

The choice of the subject as well as its arrangement on the canvas will to a great extent determine the outcome of the pictorial work. The choice of subject does not reside solely in the object that is going to be painted; it must also be located on a specific plane according to the depth the painter wants to give it.

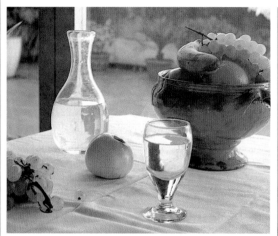

The elements of this still life have been chosen to allow the painter to paint the transparency of glass in a range of grays.

Choosing the Subject

Although any object is apt for a still life theme, from some simple pencils and magazines scattered on a table to the most intricate cooking utensils, it is essential that the elements you choose are appropriate for your needs.

In other words, if you want to base your work on transparencies and luminosity, you will want to employ such things as glass objects; if, on the other hand, you want to work with lights and shadows, objects such as books and metallic objects, should be used.

MORE INFORMATION

• Lighting **p. 12**
• Composition and balance **p. 16**
• Composing forms **p. 34**

Arranging the Objects

When you are setting up your still life, it is important to arrange the objects of your theme so that when you are standing in front of them you are able to see most of them. When you arrange the objects in a still life, you need to take into account the quantity of light as well as the shadows the objects cast on each other. You should begin to search for a compositive balance before you start to paint. When all the objects have been positioned, you should return to the place where you will paint the picture from and check to see that the arrangement is correct. You may have to add or remove one or more of the elements according to the criteria chosen.

The elements for this still life were conceived to play with the contrast between lights and shadows.

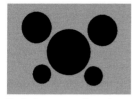

By placing components evenly on either side of an imaginary central point in a painting you can give the impression of symmetry even when they are not identical.

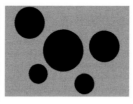

Symmetry and Asymmetry

It is not a quick and easy task to arrange a series of components for a still life. You may have to try out several compositions before you find one that is appropriate.

You may decide on a symmetrical composition even though the components are not identical.

A still life arranged in an asymmetrical manner provides a more interesting arrangement of the objects,

since a balance in the weight of the objects comes into play here, as well as the relationship of depths and the influence of light.

Creating Different Planes

The objects in a still life can be arranged in depth in a number of different ways. It is not a matter of placing one element after another. The position of the objects has to be understood as a harmonious composition of weights and masses, which should be examined from the place you will paint it from.

You have to imagine for a moment that each one of the

An asymmetrical arrangement involves alternating masses and volumes, the result of which is always more dynamic than a symmetrical arrangement of the different elements.

still life's components is on a plane seen from the front, and must be later combined together, creating masses and empty spaces accordingly.

Here the shapes are badly arranged, the planes are much too dispersed.

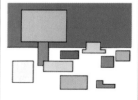

This incorrect distribution leaves the planes bunched together in the center.

This is the best distribution because the elements are arranged in a balanced manner while allowing the air to "breathe" between. The elements do not appear too close together or too isolated from one another.

Perspective and Depth in the Works by Dürer

Albrecht Dürer (1471–1528) designed several devices for making it easier to draw the subject's different planes correctly.

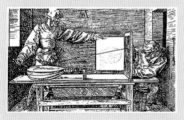

Dürer's instruments were similar to the pantograph we know today; nonetheless the great master's designs were never actually made.

LIGHTING

The foundation of any pictorial representation is light. If there were no light,
it would be impossible to see the subject, let alone paint it.
Light sculpts the objects it envelops, producing effects of great contrast
or completely flattening the contours. It all depends on what we want to
capture in the subject and then in the painting.

Types of Lighting

The artist can paint by natural or artificial light; both have their advantages and drawbacks. Daylight provides the subject with a uniform illumination and brings out the authentic colors of objects but it changes throughout the day and depends entirely on the weather.

Electric lighting can be applied to the subject as the painter sees fit. Nonetheless, it should not be so strong that it obliterates the colors. Another point to bear in mind is that artificial light produces a slight orange tint, although this does not prove too much of a problem to the artist; in fact, many painters prefer to work with artificial lighting.

Diffuse Light and Direct Light

Diffuse light envelops the subject. Normally, except under conditions of direct sunlight, daylight is diffuse. Diffuse light produces soft shadows and the colors of objects tend to be equal in intensity. Direct light illuminates the model from a fixed point, such as a spotlight or direct sunlight.

Artificial lighting can be made diffuse by reflecting it off a white surface on to the subject, or you can even counter the effect of direct light by placing a reflector (a simple piece of white cardboard or cloth) on the opposite side to the spotlight, situating the subject in the middle.

The light that directly reaches the objects of the still life hits the closest objects, producing in them strong reflected highlights.

Frontal Lighting

Frontal lighting provides the subject with the maximal degree of chromatic luminosity. It partially suppresss the contours that define the objects. Frontal lighting also makes objects stand out against a dark, color absorbing background.

To illuminate a subject with frontal lighting, the artist must direct the source of light toward the subject from the observer's viewpoint in order to diminish the influence of any shadows and thus enhance the effect of the colors.

MORE INFORMATION

- Modeling and evaluating with light **p. 14**
- Atmosphere **p. 20**
- A study of light in charcoal **p. 46**
- Light and oils **p. 70**

Here the artificial lighting has been softened by placing a screen made of white cardboard on the opposite side of the spotlight, leaving the subject in the middle.

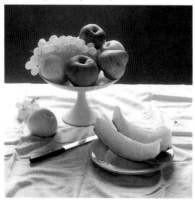

A still life illuminated with frontal lighting. This source of lighting is ideal for painting a color-intense picture of the subject since there are few shadows.

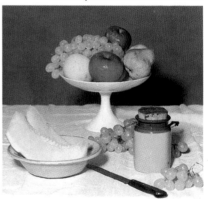

Backlighting

Backlighting is achieved by positioning the light source between the background and the subject. If you use a screen, you can alter the tones of the subject through the use of reflected light, thus creating subtle contrasts.

It is interesting to see what you can obtain by varying the light source with respect to the subject. In addition, back-lighting can be varied by the positioning of additional lights.

Backlighting corrected with a reflector screen.

Cézanne's Lighting

Cézanne was a colorist and one of the forerunners of Cubism. The colorist painter begins by subduing the shadows and gradations of form that are the result of value rather than color. To paint this type of work it is necessary to choose a completely frontal source of lighting, which cancels out the contrast produced by shadows.

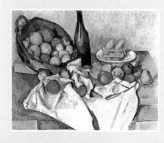

Paul Cézanne, Still Life with a Basket of Apples.

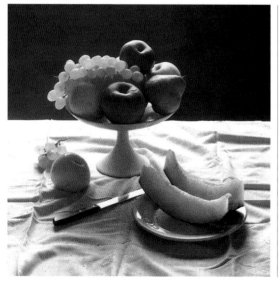

Natural and Artificial Lateral Lighting

Daylight is always softer than artificial lighting; when the light enters a window, colors appear purer and shadows are less defined and reveal more hues; this source of lighting is one of the most traditional types used by painters.

Lateral lighting from an artificial source produces more defined shadows, the highlights are sharper and brighter, and the reflections gain in intensity with respect to those produced by natural light.

Lateral light coming in through a window.

Artificial lateral lighting.

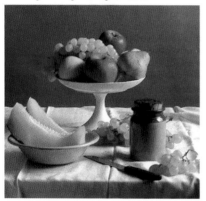

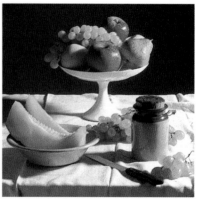

MODELING AND EVALUATING WITH LIGHT

The use of different types of lighting on a subject can have a radical effect on the volume of the object in question. The various elements of the subject are integrated in the picture by means of light. When you paint an object, you also model its forms. It is during this process that you have to understand and evaluate the forms and associate them with the actual subject.

Gradating with a Pencil

A gradation makes clear the effect of light on an object from its brightest part to the darkest areas of shadow.

A gradation in pencil allows the artist to study the way in which light acts on objects by shading according to the object's planes.

The lightest areas are created by the white of the paper, which you can then gradually darken as the light weakens into shadow.

The gradations must always follow the forms of the object whether it is curved or flat.

Modeling the Stroke

The surface of an object forms a plane that is defined by shadows when the light illuminates it indirectly. This plane will eventually become one of the gray areas of the painting. No matter what medium you are working with, when you begin to model the shape of an object, the gradations of the shadows must be made to define the form, following its curved or flat surface.

Evaluation in Realism

Modeling forms with chiaroscuro can produce surprising results when an accurate evaluation of gray tones has been made.

The light establishes the maximal points of light and shadow, particularly when light tones are placed next to areas in deep shadow. This is beautifully illustrated by this fine example of chiaroscuro painted by Jan Vermer of Delft.

*Vermer of Delft,
The Milkmaid.*

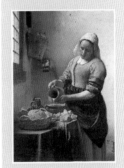

In this gradation, the pencil strokes model the forms in a directional manner.

The surface of forms varies in tone according to how much light these receive. However, the shadows are never flat, in that they also envelop the object.

The gradation of these objects comprises a different tone in each area, increasing the intensity of gray in the darkest areas.

Composing and Evaluation

When we are studying the effect of light on the different elements of a still life, we must begin by evaluating the different gray tones, indicating from the outset the areas of maximal shadow and those of maximal light.

In this way, the grays are evaluated gradually, using the maximal values as a reference.

When the intensity of black in a dark value is increased, the values of the intermediate intensities have to be heightened as well, thus producing greater contrast.

In this drawing of a plaster model, the painter has shaded the areas of maximal darkness with black, which have then been slightly lightened in order to allow the forms within the area to be modeled.

From the beginning of the drawing, you must gradually develop the gradations of the figures until you achieve the desired contrast.

Gradations executed with pencils of different hardnesses: the lightest one is a 2HB, medium hardness; the darkest is a 4B, a very soft pencil that produces deep blacks.

Evaluation and Contrast

When we want to capture the shapes of a still life, the pencil must be used to evaluate which parts are black and which are white.

You must not falter when confronted with a maximal intensity of darkness, in that the pencil has its own limitations in achieving the degree of darkness desired.

MORE INFORMATION

• Lighting **p. 12**
• Light and oils **p. 70**

When you observe a subject, you must establish these darkest areas, which are then used as a guideline in developing the value relationships to all of the other areas, including the middle values and highlights.

COMPOSITION AND BALANCE

Composition is the art of distributing the elements of the subject in an esthetically pleasing arrangement. Among the many pictorial themes, the still life is the most apt for this task for the simple reason that the objects of a still life can be moved around with greater ease than furniture, people, or, of course, a landscape.

Weight in a Composition

In addition to the still life's material components, other elements and factors have an important role to play in the composition. So when an artist

The lighting can disperse the weight between the different elements in the composition.

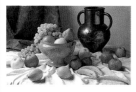

The Balance of Simplicity

The composition of a still life need not be complicated; balance can also be obtained by rearranging forms within the format of the painting, that is, the relationship of the composition to the proportions of the canvas.
Francisco Zurbarán (1598–1664) painted this famous still life during his youth by balancing the composition not only by the shapes of the objects but also by the weights of colors.

Francisco Zurbarán, Still Life.

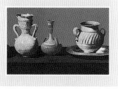

begins to arrange the elements of the subject, he or she must bear in mind how they will influence the painting.

The effect of light, for instance, is of critical importance because it affects the composition and the balance of individual and grouped objects, and thus should be controlled at all times. Shadows produce visual weight, especially when they are the result of direct light.

Furthermore, there is the question of those objects that surround a still life, such as tablecloths, walls, or almost any type of background. A creative use of these elements can lend the painting a lot of compositional interest.

Excess Unity

The still life's components can be distributed in as many ways as the painter wants, but he or she should avoid uninteresting compositions. The composition should not have excessive unity; in other words, the elements should not be bunched together into a singe mass and be lost within a large space.

Esthetically speaking, the result of too much unity is boredom.

The effects of a composition with excess unity.

Again, excess unity produces an awkward composition.

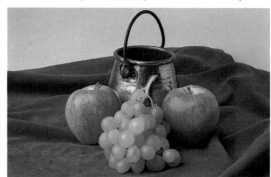

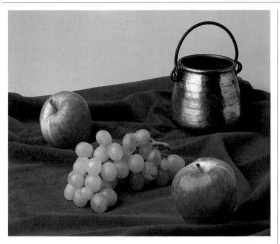

The dispersion of the objects in this composition appears uninteresting to the spectator and, furthermore, the unrelatedness of the arrangement lacks a center of interest.

Compositional Coherency

Composition is the skill of finding and representing unity within variety. It is the irregular placement of elements on the canvas which, by sensitive arrangement and a creative use of lighting, take on a unity that is inexplicable yet pleasing, or even exciting, to the spectator as a unique visual experience.

With the right composition, the observer's gaze focuses on the center of attention instead of scattering aimlessly around the painted surface.

Diversity and Dispersion

In the art of composition it is very easy to distribute the elements too widely within the area of the canvas. Every picture must possess a center of interest, an area that makes the spectator see the work as a balanced composition.

When the objects of a painting are too scattered, they attract attention separately and fail to make up a homogenous group. This distracts the spectator's eye toward a number of unrelated elements about the canvas.

When the composition has coherence and variety, the spectator's eyes are drawn toward the center of attention.

MORE INFORMATION
• Essential compositional forms **p. 18**
• Dimensions and proportions **p. 24**
• Composing forms **p. 34**

A solid composition must keep the spectator's attention focused on the center of attention within the dynamism of their forms and colors.

A composition in which the objects are too dispersed makes them appear unconnected and thus unbalanced.

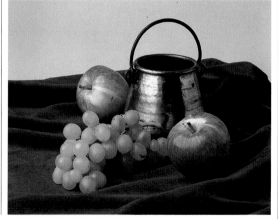

ESSENTIAL COMPOSITIONAL FORMS

The still life is an excellent theme for practicing composition.
In themes such as portraits or landscapes the composition is often
subordinated to a fixed subject, whereas in the still life the artist is free
to arrange the elements as he sees fit.

The Still Life and the Rule of the Golden Section

The rule of the golden section is a mathematical distribution of forms within a canvas. It establishes the proportional ideal between the format of the canvas and the objects of the composition.

To find this ideal division, you have to multiply the width of the canvas by the factor of 0.618. The result is the length of the width that is proportional to the whole. Then the same is done with the vertical length of the canvas. Note that the golden point is where the horizontal and vertical lines intersect. This is the exact point of the picture's center of interest. In fact, there are four such golden points where you can place your main subject.

Note that the rule of the golden section is no more than

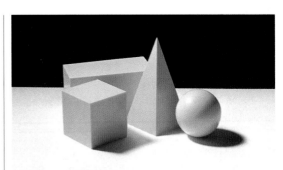

This solution is monotonous and visually uninteresting.

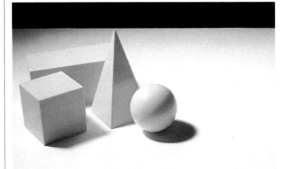

The composition becomes more interesting by moving it over to one side, but the picture is now unbalanced.

MORE INFORMATION

• Composition and balance **p. 16**
• Dimensions and proportions **p. 24**

Situating of the lines and the golden points permits us to locate the ideal composition, the result of multiplying the length and the width of the canvas by the factor of 0.618.

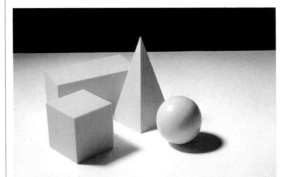

The use of the rule of the golden section gives us harmony.

a classical hypothesis adopted by artists throughout history.

Compositional Schemes

The composition of a still life can be reduced to a completely geometric scheme by manipulating the various elements that participate in the painting. This type of composition enhances the work since studies have proven that people are particularly attracted to geometric forms.

A geometric composition can be obtained by arranging the elements of a painting in the shape of a cube, for instance.

In this scheme you can see how all objects can be reduced to basic geometric shapes.

Triangular and Truncated Cone Compositions

The triangular composition is one of the most effective because it allows the greatest variety of combinations. This type of composition is highly balanced and the elements of the painting may be distributed very freely while ensuring a balanced result.

A triangular compositive scheme.

A compositive scheme in the shape of a truncated cone.

The truncated cone-shaped composition, like the triangular one, is very appropriate for a still life, since it has a wide base and the objects can be arranged in a staggered formation that leads into the distance.

L-shaped Compositions

This type of composition allows for a large number of combinations. It permits the

The elements of this composition have been distributed in the form of an L.

painter to develop various planes within the L shape, with the square fragment acting as an independent plane that is used as the background of the whole.

This square area may be filled with a room, a curtain, or it may simply be left as an abstract shape.

Circular and Elliptic Compositions

These composition types are suitable for the still life theme with objects that possess more organic volumes, that is, shapes that can be perfectly synthesized within a circle or an ellipse.

Both the circular and elliptic compositions would be most suitable in themes such as a basket of fruit.

An elliptic compositive scheme.

Rembrandt's Composition

Among the many compositions used by Rembrandt, the division of a space into light and dark areas appeared to be the master's favorite. In order to obtain a balance in this type of composition, not only do you have to play with the masses of the objects but also consider their presence as an element within the chiaroscuro.

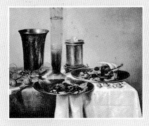

An L-shaped compositive scheme.

THE MEDIUM

ATMOSPHERE

The atmosphere of a painting can be defined as a pictorial effect
created through the space that separates the different objects.
The still life is a perfect model for studying atmospheric effects in a painting,
regardless of the medium you use.

Atmosphere by Means of Oils

The still life in oil is an excellent medium for creating atmospheric effects. The painting can comprise a series of planes, that is, a surface on which a number of objects are situated more or less one behind the other.

Atmosphere can be created by means of gradual glazes that alter the tones of the planes. Atmosphere can also be achieved from the outset by painting the most distant planes with a value of grays, using only the tones within the chromaticism of the foreground in order to obtain an overall unity.

Atmosphere and Watercolor

Watercolor does not allow the painter to employ white, in that in this medium the color white is provided by the color of the paper. Therefore, the atmosphere can only be created by gradually and subtly reducing the intensity of the colors as the planes recede into the background. In this sense, watercolor has the added advantage that the painter can superimpose one tone on another; that is, if the difference in tone between planes is small, it is always possible to apply a subtle glaze to intensify the tone of the nearest plane, thus separating it from the more distant ones. Another procedure for creating atmosphere with watercolor is to apply very transparent uniform washes over the more distant planes.

The atmosphere in this still life has been created in two ways: painting on wet and then applying glazes over dry.

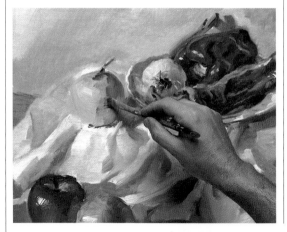

The accentuation of the different objects in a still life by means of tonal evaluation produces an atmospheric effect.

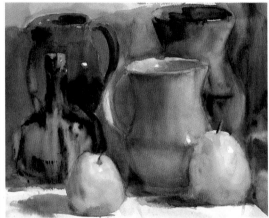

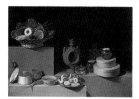

This scheme shows the variation in tonal intensity between the planes of a still life. Juan Ven der Hamen y Leon, Still Life with Confitures and Pots.

Difference in the Intensity of the Planes

In order to create atmosphere in a still life there should exist a variation of intensities of light on the different planes. The different tones of color can provide effective atmospheric depth

Atmosphere, Volume, and Highlights

In this work by José Casber, the transparent and opaque areas were painted in oil without the use of glazes. The atmosphere was created with a warm color range, which the painter turned into brown as the planes receded into the distance.
As a result, we have a nearly perfect compositional and chromatic balance.

José Caber,
Uncle Manolo's Things.

between the different objects of the composition, provided the tones are gradually gradated as they recede into the background. The foreground must be the most intense plane, containing a variety of tonalities and textures on the different objects. The middle ground, which should be more subdued, should display some contrasts of light. The background must contain few tonal variations, leaving only subtle light areas visible.

The Highlights in a Still Life

Atmosphere can be obtained by playing with the composition of the different highlights and other intensities of light on the objects.

First you have to understand the different placement of light in the still life, and then apply a tonal gradation on each of the objects so that there is a clear difference between the areas of light.

The way you apply highlights depends on the pictorial medium you are painting with. Opaque mediums allow highlights to be applied over dark areas; with watercolor, on the contrary, the areas of maximal light are kept free of paint from the outset.

Scheme of an evaluation of highlights. Giuseppe Recco, Still Life with Bread, Cake, and Ham.

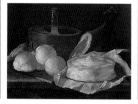

Separating the Different Planes

One way of obtaining a division between planes consists of developing a unity within each plane.

This division can be achieved by the ways in which the different planes are represented: the foreground is painted with maximal color intensity, whereas the volumes in the middle ground are heightened through contrast. Finally, in the last plane, the objects are blended in with the background.

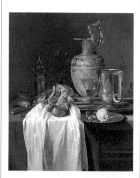

Willem Kalf, Still Life of a Pomegranate. *Although each one of the planes in this work has been resolved separately, it is the chromatic unity that provides the harmony.*

MORE INFORMATION

- Contrast **p. 38**
- The background and the motif **p. 88**

ORGANIZING THE PALETTE

Artists can organize their palette according to two considerations: the chromatic range they wish to use and the part of the spectrum they want to paint their picture with. The possibility of mixing primary colors to obtain the rest of the range is an available option, but without doubt, it is always best to have a palette containing a wide range of tones and colors. A good example of where this is important is when you paint with pastel, a medium that does not permit color blending.

This palette shows a classic arrangement of colors that, from left to right, includes the range of cool and warm colors and ends with white.

Order and Method

Each artist has his or her own preferences as to how the palette is to be arranged. However, whether you are a

The arrangement of colors on a warm palette.

complete beginner or an experienced painter, you can sometimes make mistakes that must be avoided in order not to hinder the progress of the work.

The palette should be cleaned every time you begin a new painting session, so you are not influenced by the previously mixed colors. Never attempt to apply colors at random; instead, try to use the rules of color to serve your creative needs. You should reserve an area on your palette that is large enough to mix your colors on. If you find that there is not enough space, you may have to use an additional surface for mixing.

Order According to the Predominating Color

Although each one of the chromatic ranges can produce completely different palettes, and a palette can be as per-

A cool range of a greenish yellow tendency.

A warm range of a reddish ochre tendency.

A neutral range of violet-blue.

This warm palette maintains its tonal relationship between the warm colors, leaving the blue separate.

sonal as your signature, you must, nonetheless, maintain some system of tonal order. For instance, you may arrange the colors by their tonal intensity; that is, from the lightest to the darkest.

Palette and Solvent

Every painting medium is composed of pigment, medium, and solvent. When we mix paint on the palette we use solvent to thin it.

The use of painting medium as a paint thinner normally produces greater transparent luminosity than when only solvent is used. The medium for oil paints (walnut or linseed oil) does not dry solidly on its own, so a small amount of turpentine should be added to it.

The solvent in watercolor is water and the binder is gum arabic; watercolor glazes do not require the binder, just a touch of glycerine in order to slow down the drying process, or alcohol in order to increase it. The acrylic palette must contain a holder for the water and another one for the acrylic binder, since this type of paint loses its medium characteristic if too much water is added.

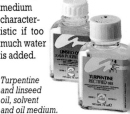

Turpentine and linseed oil, solvent and oil medium.

The colors of objects vary according to the colors of the objects that surround them.

The Palette and the Still Life

The lighting you use on a still life will always have a direct effect on the colors. Lateral lighting produces soft shadows, while at the same time the color appears pure and gradated (unless the sun is shining directing on the

Depending on the technique you are using, you should have one receptacle for the medium and one for the solvent.

subject) and the illuminated parts acquire a natural chromaticism. If the model is situated in a warm atmosphere (ochre walls, red curtains, a dark wooden table...), the still life will be bathed in this warm light, and the palette must be made up of colors that are of a similar chromatic range.

If artificial lighting is used on the subject, it is always possible to modify its tone by placing color filters in front of the bulbs, or by setting up screens to reflect the light. The palette will then have to be adapted to the subject's new colors.

Illumination in the Palette

You have learned in earlier chapters how to illuminate the subject, but you should also be aware that your palette must be appropriately illuminated as well.

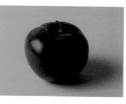

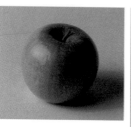

Color is conditioned by the type of lighting cast on the subject.

Never use yellow bulbs or warm fluorescent lights to illuminate your palette, since they tend to alter the appearance of colors. The best solution, therefore, is direct or indirect daylight or a blue bulb with a silver reflector or cool fluorescent tubes in order to avoid annoying color distortions.

Never illuminate your subject and your palette with the same light source; the palette should be lit with a cool light source.

Color Synthesis

Most professional painters do not put all the colors they have onto the palette. They begin with the theme's most basic colors and then gradually add more colors, particularly those colors that cannot be obtained quickly by mixing primary colors together.

A professional's palette.

DIMENSIONS AND PROPORTIONS

Regardless of the elements you choose for your still life, they must be arranged in a composition that is both balanced and proportioned in an interesting way. On the one hand, proportioning the elements in the still life will serve as a guide throughout the whole process, and on the other hand, the relationship of the objects to the borders of the canvas will also influence the overall arrangement of the elements in the painting.

Observation and Study

The artist's choice of subject is never gratuitous: he or she selects it and then imagines what it will look like on the canvas. However, there is a series of factors that must be taken into account before and during the execution of the painting that will be determined by the subject itself.

The format of the subject's composition must be adapted to fit the format of the canvas, and the different objects must be proportionate to the existing space so that when placing the different elements of the subject, you also compose the surrounding area.

Approximation of Dimensions

The different objects of the theme can be adapted to a scheme that permits the painter to transfer the size of each one of the subject's parts when placed onto the canvas. This procedure of transferring the dimensions of the subject onto the canvas is not difficult once you understand it.

If the subject is symmetrical you should first establish its shape by using simple geo-

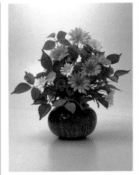

The model should be carefully studied to determine the proportions.

metric forms. It is then easy to find the vertical axis: divide the forms into two by drawing a horizontal line and then find the center. From this starting point, you can determine the definitive proportions.

See in the figure below how with two measurements (A) and (B) you can establish the proportions of the widths of the two forms.

Imaginary lines are drawn in order to work out the position of the different parts of the subject.

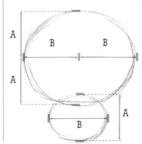

Construction and Elaboration of the Figure

Once we have the initial proportions, we can easily work out the rest of the measurements.

Now we will find the horizontal axis in a similar way as before by drawing a vertical line in the middle and finding the center. Then we have to find any related measurements

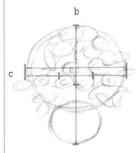

By dividing the lines proportionally we can establish references that help us to transfer points of the subject onto the canvas.

Once the schematic lines have been drawn, we can draw and then paint the subject.

MORE INFORMATION

• The subject **p. 10**
• Framing and composing in practice **p. 32**
• Composing forms **p. 34**

A Pencil to Measure Sizes and Dimensions

One of the simplest ways of resolving the sizes and dimensions of an element is by measuring the width and height of an object with that of another object (a).

By holding the pencil out at arm's length and using your thumb to indicate the size, you can transfer the measurements from the model to the canvas (b).

Schematization of sizes and dimensions.

Not only do you have to position the forms but also establish the proportions within the space.

within the subject in order to work out the different heights (segment b is similar to c and the sum of these two segments is then divided into three identical segments).

In this way we gradually transfer dimensions and reference points from the subject to the painting.

Once the main reference points have been indicated, the drawing can be developed with more detail.

The Quick Scheme

A very simple way of determining the general composition of the painting is to draw a rectangle that tightly encloses, or boxes, the forms you are representing.

When a still life consists of several elements, the relationship of dimensions should be dealt with individually and as a whole, calculating the distances between the objects in the same way it is done for each one of the individual elements.

This first scheme may consist of a simple construction in which the forms are synthesized by using geometric forms.

Finally, a simple way to resolve the composition once this first scheme is completed is to consider the rectangle as an element of your painting.

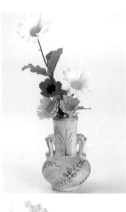

Drawing Without a Scheme

It is possible to draw a picture without an initial scheme, but this type of drawing is closer to the expressionist style rather than the purely academic.

A non-academic procedure is to view the elements as lines or simple shapes. In such cases the space would be resolved by considering the shape's volumes.

The general shapes of the subject can always be constructed in rectangles that approximate the shapes.

SUPERIMPOSING PLANES
IN A STILL LIFE

One of the most important aspects of a composition is the creation
of a series of planes on which the different objects of the subject are located.
A good way to understand this is to think of the way in which the wings of a theater
are used to give the sensation of depth. In the still life the representation
of the objects on different planes is one of the most important
aspects of compositional study.

The Planes in the Subject and in the Picture

From the artist's viewpoint in painting a still life, the different elements appear on a plane with two reference points that indicate their position. One is the location according to perspective, with a slight reduction in those objects that are farthest away as they recede toward a vanishing point. The other one

Apples A and B slightly superimpose those behind them.

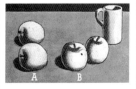

In this case, the setup is excessive and the unity of the whole is lost.

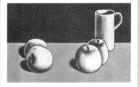

Here the superimposition of planes is balanced, a sensation of depth has been obtained in the painting.

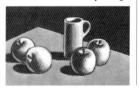

is the position of the objects themselves.

To resolve this second problem, you must concentrate on the object itself in order to determine the most convenient perspective to use.

Inclining Planes

The superimposition of planes depends to a great extent on the observer's viewpoint, be it close up or from a distance.

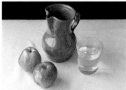

An elevated viewpoint from close up makes the subject appear to slope away.

When the subject is observed from an elevated viewpoint, the objects appear to drop away from you. If the painter steps back a few feet or sits on a high stool, he or she will view the subject from a normal viewpoint, which

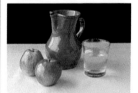

The most common viewpoint is obtaining from a seated position at a distance of five feet from the subject.

A low viewpoint makes all the elements appear to be on the same plane.

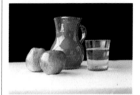

produces the most acceptable layout of the planes. If the painter chooses a low viewpoint, almost at eye level, he or she will get a rather unusual

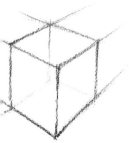

frontal view in which all the elements in the composition appear to be on the same plane.

Perspective and Superimposing Planes

Perspective plays an important role when the viewpoint of the subject is inclined in such a way as to produce a foreshortening. In this case, it is important to bear in mind the plane on which each of the elements is located, and above all to remember that there exists at least one common plane, that of the earth (horizon line).

Felipe Santamans, Still Life. The separation of planes by means of the distribution of light is obvious in this still life. In this composition the planes are separated by colors.

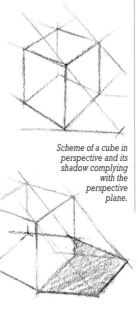

Scheme of a cube in perspective and its shadow complying with the perspective plane.

Light and Synthesis of Planes

The way in which light strikes the objects of a still life can also determine the planes of a painting. When light shines on a still life, the different objects receive a greater or lesser amount of light depending on where they are situated, thus creating a series of relationships between them. This method of creating planes from light can be seen very clearly in chiaroscuro, in which the elements are more or less illuminated according to the plane on which they are situated.

Distance Between Planes

The separation between the different planes can be resolved by means of a number of plastic and pictorial methods, such as providing variations in the illumination of different planes, or painting the more distant planes in a soft, somewhat blurred technique, while emphasizing the details of the elements on the closer planes.

From a compositional point of view the distance between the planes can be varied by painting the still life from a slightly higher viewpoint than is the norm.

Separation of planes by chromatic contrast.

Separation of planes by the inclination of the earth's plane.

Separation of planes by value contrast.

MORE INFORMATION

• The subject **p. 10**
• Dimensions and proportions **p. 24**

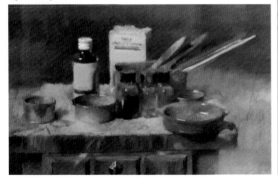

DIFFERENT MEDIUMS

The still life can be interpreted using a wide range of mediums. The way in which the different styles and techniques are adapted to the still life theme depends to a great extent on the artist's creative capacity, but the painter should also bear in mind that each painting medium demands its own techniques, which must be mastered before they can be applied successfully.

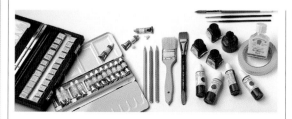

Watercolor painting materials.

Like watercolor, acrylic is soluble in water and should be kept constantly moist because it dries very rapidly. When not in use, brushes must be kept immersed in water.

Watercolor

Watercolor is the most transparent and color-intensive medium for painting still lifes. The preliminary drawing is the foundation of a watercolor, a fact that becomes evident throughout the entire process. Watercolor painting involves executing delicate glazes that can be alternated on a wet surface while at the same time allowing the colors to blend with one another, or on a dry surface, allowing each area to be dealt with individually in order to stop the colors from mixing together.

This still life was painted in watercolor. The color white in this medium is provided by the white of the paper showing through the translucent paint.

Acrylic

Acrylic paint is the greatest plastic invention of the twentieth century. Acrylic dries rapidly and can be applied thinly like watercolor or at full strength like oils. The transparent and opaque properties of acrylic can be employed in the still life to create interesting plastic effects. The opaque characteristic of acrylic allows the painter to carry out changes at any moment during the painting session. A still life in acrylic can be painted on paper or canvas. In short, acrylic is probably the most versatile paint ever developed.

Acrylic painting equipment.

Acrylic paint allows for both transparent and opaque techniques and dries rapidly, thus making alterations easy.

Pastel

Pastel can be applied over almost any type of surface. However, due to the dry character of pastel crayons, a textured surface is recommended because the roughness

MORE INFORMATION

• Pastels. An introduction to color **p. 48**
• Watercolors. Colorism and value painting. Technical appl. **p. 54**
• Alternative tech. Tempera **p. 64**
• Combined techniques **p. 92**

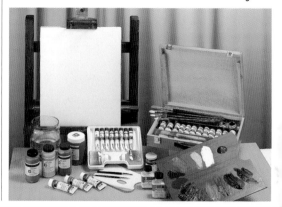

Superimposing Planes in a Still Life
Different Mediums
The Initial Painting and the Form
29

of such surfaces tends to grab at the particles of crayon. Other good surfaces for pastel are cardboard, unprimed canvas, and sandpaper.

Gouache

Gouache has somewhat the same compositive base as watercolor, only it is completely opaque. This characteristic allows colors to be super-imposed. Gouache is an ideal medium for representing flat surfaces and produces a highly luminous effect.

Like watercolor and acrylic paint, gouache is soluble in water, but has the added advantage of dissolving even after it has completely dried, a unique characteristic that permits the painting to be constantly washed away and repainted.

Gouache can produce a great variety of plastic effects, from tonal gradations for

Oil enables the artist to paint subtle tonal gradations as well as direct blends on the canvas.

A still life painted in gouache. The painting is completely opaque and the colors are flat, but this medium also allows you to paint a picture consisting of subtle blends and gradations.

painting a still life emphasizing value, to the execution of a completely flat and shadow-less colorist painting.

Oil

Oil can be used to paint in a wide range of styles, from the most realistic work to an abstract expressionist painting.

With this medium the initial drawing does not have to be definitive, since you can develop the subject as you paint.

The most significant characteristics of this medium are its opacity, its brilliance, its stability when exposed to light, and the opportunity of creating a phy-sical texture over the surface of the

painting. Unlike other wet me-diums, oil has a linseed oil base that requires turpentine as a solvent.

THE INITIAL PAINTING AND THE FORM

Once the subject has been composed, the artist can begin painting the canvas. The initial painting process is so important because it affects the future outcome of the work. The roughing-out process resolves the problems of form and space, but is not used throughout the entire process of the work. Depending on the medium used, the artist must follow one or another guideline, since each medium has its own particular techniques and plastic characteristics.

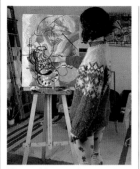

The roughing-out of a gestural painting is its most influential feature.

The Painting and the Underpainting

Whatever the medium you paint with, the underpainting process is always the first step on the road to painting a picture. The underpainting allows the artist to understand the subject by means of his or her brushwork, the first synthesis of form and color. Many contemporary painters attach so much importance to the underpainting that they leave it as it is, rejecting further details.

Gestural painting is based on creating planes out of the initial brushstrokes in order to develop the painting's different color masses.

The underpainting and the drawing in gestural painting are closely associated, especially when the painter does not want to allow the paint to obscure the basic drawing and thus lose the details of the subject.

The Underpainting and Construction of the Form

When we are establishing the shapes of a still life's elements, the initial brushstrokes indicate what form they will take as the painting develops. The construction of an object depends as much on the form as the color. A value painting requires an initial study of lights in order to paint the tonal gradations. It comprises a series of rough applications that construct the form within the value, indicating dark and light areas.

A colorist painting is constructed by defining whole forms with brushstrokes of vivid and flat colors, filling the designated area with spontaneous brushworks, without the need of chiaroscuro; in a

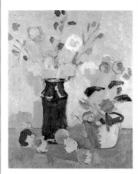

The initial painting of forms in a value painting. The first paint applications indicate the different areas of lights and darks that will later on be developed into gradated forms.

Vivid and flat colors characterize a colorist painting. Its planes lack chiaroscuro.

In the pointillist style the brushstroke is not employed. Rather, the forms are developed by means of a series of brush-point dots.

Different Mediums
The Initial Painting and the Form
Framing and Composing in Practice

31

The superimposing of washes in watercolor.

colorist painting, color defines the planes and forms by itself.

Superimposing Color Areas in a Still Life

By superimposing different color areas you prevent the painting from appearing dense, since the underlying colors breathe through the planes.

In watercolor, the superimposition of layers helps to bring out the forms by adding color to the first glazes. The initial application of a watercolor is carried out with very transparent paint unless the color applied is to be definitive.

In opaque mediums the color areas are applied directly or by blending.

White reserved areas toned with a subtle wash.

Areas of colors effected on a wet surface.

Color blend on wet surfaces.

Dark tones over a lighter dry surface.

Direct superimposing

Color blend applied to the background.

After the initial underpainting, the background remains visible in some areas.

Superimposing layers by means of gradation.

Example of the superimposing of layers with an opaque medium.

The Color Areas and the Medium

Each medium has its own method of application. In watercolor, you start out with a transparent wash that allows darker tones to be superimposed on top; in oil and acrylic, the underpainting consists of alternating transparent layers with color densities according to the desired result; underpainting in pastel involves drawing and painting; that is, applying lines and color masses.

Underpainting with plenty of turpentine within the oil medium.

An almost definitive watercolor initial application.

Initial application of form and color executed in pastel.

Composing, Painting, and Forms

After composing the subject's different forms and defining the different planes of the objects, you will see how the underpainting has got to be carried out. This process will then bring out the shape of each object.

Composing helps define the different color areas and their mutual relationship, either by superimposition of planes (colors superimposed so as to establish a contrast), or by blending (the color areas blended so as to obtain a gradation).

MORE INFORMATION

- Brushwork **p. 52**
- Painting in acrylic **p. 72**
- Painting in oils **p. 78**
- Painting in watercolor **p. 82**

FRAMING AND COMPOSING IN PRACTICE

Framing establishes the limits of the subject for the chosen format.
Until the subject has been framed on the paper or the canvas, we cannot say that the
composition of the painting is complete.

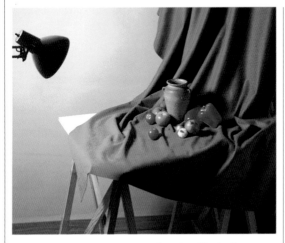

Framing and Composing

Framing should not be confused with composing. The first thing the artists should do when studying a model is to choose which part of it and the surrounding area they are going to paint or draw. Once they have decided, they then compose the subject using as a basis the particular frame they have selected.

Composing forms part of the process of painting the still life, whereas the framing decides in what area the painting is going to develop.

Composition and Framing

Your subject usually should have a certain format that matches the format of the canvas or the paper. You should mentally transfer this format to the still life, adjusting the area until the masses of color are properly distributed.

Once the subject has been set up, it can be framed as large or small as desired.

A small cardboard cutout may help you to decide which is the best frame.

Two Ls are cut out of cardboard and are then joined to form a frame that matches the chosen format. By looking through this frame and then removing it, the best dimensions for the composition can be found.

Sketching or Composing a Still Life

Once the frame has been decided, the various elements can be arranged in accordance with the proportions of the surrounding area. When positioning the elements within the painting, you should remember that drawing the area surrounding the main elements is just as important as drawing the main elements themselves; this area should be treated not as empty space but as another element within the drawing.

To avoid confusion later, the lines used when composing a still life should be as accurate as possible. All of the objects should be drawn in a simple, generalized manner.

No tonal development is needed in the sketch; only clear lines.

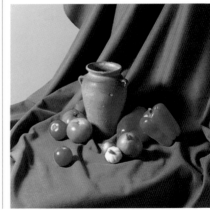

Framing enables the artist to see the subject as it will appear in the finished painting.

The Initial Painting and the Form
Framing and Composing in Practice
Composing Forms

33

Composing Colors

After making the sketch, the aim is to capture the colors of the subject. In this process, applicable to all the wet mediums, a highly diluted, almost transparent color is applied, except in those areas where the highlights of the painting are to be.

Oils and acrylics are opaque mediums. Nevertheless, both can be worked transparently, with darker layers of color added later. Watercolor is a naturally transparent medium, and the process of initial un-

Paul Cézanne's Manner of Composing

Cézanne (1839–1906) did not make a prior drawing when approaching his paintings. He would always compose when painting, using only a few brushstrokes to define the forms and then to construct them with color. He would organize the

color over the entire area of the painting at the same time, not confining himself to constructing and evaluating each particular area individually.

Paul Cézanne, Still Life with Vase. *Unfinished work.*

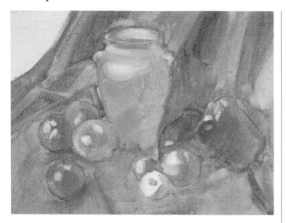

The colors are highly diluted when applied.

Superimposing more definite colors.

derpainting is followed by adding glazes to achieve the desired color; that is, to allow each layer to dry first while leaving the most luminous areas unpainted.

Modifying the Color

The almost transparent base colors are then modified by increasing the contrast and reinforcing the forms by using opaque colors (only for opaque techniques: acrylics, oils, or tempera). The brushstrokes indicate the areas of color and tone, allowing some of the underlying tonality to show through. In this case, the initial

applications of paint are followed by layers of more dense and opaque color, which are, of course, modified by mixing the colors on the palette.

Modifying the color on the palette to that of the subject.

Developing simultaneous contrasts; white is reinforced by an adjacent dark tone.

MORE INFORMATION

- Composition and balance **p. 16**
- Essential compositional forms **p. 18**
- Composing forms **p. 34**

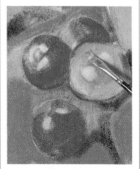

The definitive colors are dense and opaque.

TECHNIQUE AND PRACTICE

COMPOSING FORMS

It is in still lifes, more than in other themes, that the various elements of the painting can be seen as geometrical shapes. This leads to a more spatial interpretation of the subject than when doing a more detailed sketch for the painting. Composing helps to synthesize the forms, to define the space that surrounds each of the elements of the still life, and to grasp the different planes on which the objects are situated.

Learning to See

A still life is not just a set of objects placed against a background. A still life painting requires the artist to carry out a thorough study of the scene he or she wishes to depict.

Such a study requires the artist to establish the relationship among the elements through the use of imaginary lines. This locates the objects in a particular place in space, while establishing the relationship between proportion and size.

Every element within a still life is a reference point for the size of all other objects.

Learning to see the objects in relation to the planes they occupy; that is the key to still life painting.

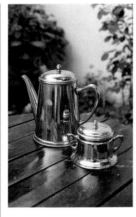

Essential Forms

However complicated the forms of the subject appear to be, they can be developed quite simply by using broad masses of color, with no attempt to produce tones or atmosphere.

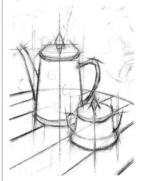

The subject should be seen as a set of basic forms within a given space.

In other words, when you observe the subject, you should paint just the essential, roughly outlined forms. For example, in the case of a still life comprising a vase, two apples, and a bunch of grapes, the first impression of the different elements should be that of a group surrounded by a given space, with the emphasis placed on the essential forms of all the elements. Attention to detail should come much later.

Concise Lines

Once you have captured the forms of the subject, the drawing should be based on the basic shapes of the different elements.

This initial approach to the subject should be clear and straightforward, while at the same time attempting an overall organizing of the

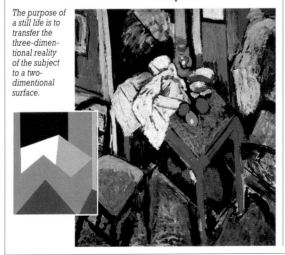

The purpose of a still life is to transfer the three-dimentional reality of the subject to a two-dimentional surface.

subject. All detail is omitted, and elements are reduced to pure geometrical shapes.

Above all, you should keep in mind the different sizes of elements and their spatial relationships within the painting.

The construction of the subject should be simple and unadorned.

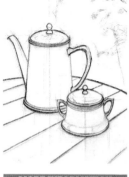

MORE INFORMATION
- Dimensions and proportions **p. 24**
- Framing and composing in practice **p. 32**

Composing for a combined technique, alternating transparency and opacity.

Understanding Forms

Extreme accuracy is not necessary for understanding the forms contained in a still life; it simply requires practice at synthesizing them. Here, Esther Olivé has summarized the subject with just a few lines, only enough to prepare for the final painting.

Synthesizing Space

It is easier to define forms if you are aware of the space that surrounds them as being another element of the painting. This involves not just the objects represented in the still life but also the relationship between the painting and the chosen framing.

There are many reference points for arranging the still life in the painting. The sizes of the objects are compared not only among themselves but also to the way in which they relate to the surrounding space. This approach allows all of the elements in the painting to form a unified whole.

Different Composing Techniques

Each medium has its own particular way of developing. We should differentiate, above all, between two composing forms: one for watercolors and other transparent techniques and another for opaque mediums. Watercolors require very careful, meticulous development in that this initial stage will be visible in the final result. With opaque techniques, however, the artist has more opportunity for making corrections. The painting can be more freely developed as one goes along, allowing for a more general, rough form of composing.

Composing for an opaque technique.

A QUICK TECHNIQUE

Before attempting a "quick painting," you must first decide which medium to use. Each medium has its own "quick" or *alla prima* character, although two stand out among the rest. One is pastel, a direct and spontaneous medium, and the other is watercolor, which dries quickly and can produce a wide chromatic range using just a few colors.

Other techniques such as oils or acrylics can also be used for quick painting, but these, because of weight and bulk, are more cumbersome than those mentioned above.

Quick Sketches in Pastels

Although pastels are completely opaque and do not allow the use of glazes, they do allow the artist to rapidly capture the forms and planes of the different elements in the still life stand.

Pastel sketches are made without using any other tools such as a pencil or brush. It is applied directly, so adding forms to the painting can be done instantly. Composing can be done using different colored pastels, outlining the forms of the still life in tonalities within the same chromatic range as those to be used in the overall painting itself.

Composing in pastels is done directly with the pastel itself, adding the colors one at a time.

When colored paper is being used, the white pastel is useful for creating highlights and thus volume.

Sketching continues by modifying the colors of the subject without prior mixing of the colors, adding slight hues to the elements in order to model their forms.

Using Your Fingers to Paint

Pastels are mainly worked with the fingers. Beginning with a pastel sketch in two different colors, the colors can be blended together with the background by simply rubbing

A surface blended into the background of the paper.

Blending tones with the fingers.

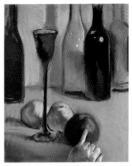

Tonal fusion in practice.

your finger in zigzag fashion across the surface. When the colors have been blended together over the unpainted areas, a strong feeling of volume can be developed.

Any further hues can be added to a surface painted in pastels, and then merged by way of rubbing into the background.

Applying a darker color to strengthen the tone.

MORE INFORMATION
• Pastels. An introduction to color **p. 48**
• A quick sketch in wax crayon **p. 56**
• Painting with watercolor **p. 82**

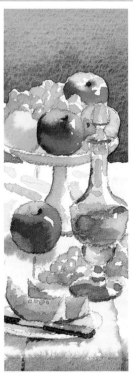

All the forms in this still life were painted separately, allowing them to dry before applying fresh layers of glaze.

Watercolors and Quick Painting

Watercolors are the perfect medium for painting quick still lifes in which the main elements are the underpainting and the blending of colors.

Starting with the initial drawing, the entire area of the background is dampened, while defining the areas must wait until later. Umber is then applied to the damp surface, using the brush to apply most of it to the lower part of the painting. The rest of the areas of the still life are painted in the same way as the background, making sure to let the paint dry in those areas where we want the color to remain unchanged.

Chromatic Simplicity and Tonal Range

A wide range of colors is not necessary for quick painting, but the artist must master the use of at least three or four colors. Depending on the technique being used, the color of the paper can be used to harmonize the colors chosen, at the same time limiting the amount of area covered and thus allowing the underlying color to show through.

Synthesizing Forms

One of the basic questions in quick painting is how to synthesize the forms. The success of a painting depends on this from the outset. A subject that is properly developed may require just a few additional highlights to look like a finished work. Synthesizing the different elements within a still life consists of reducing them to shapes that define both the form and the composition as concisely as possible.

Edouard Vuillard, The Set Table.

Spontaneity and Speed

Quick painting in still lifes makes it possible to produce direct, spontaneous studies of the subject, when perhaps another technique would not be possible. Here, Edouard Vuillard (1868–1940) gives us a magnificent example of the synthesis of a table with food. This still life was produced in only a few minutes. The surface of the table is, in fact, the color of the paper itself. Proper synthesis expresses a great deal when using the very minimum.

Synthesizing forms means reducing the still life to its essential forms.

Starting with a good synthesis of the forms, a further synthesis of the light is then incorporated.

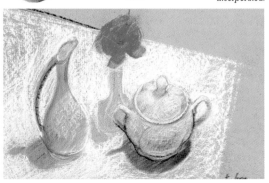

CONTRAST

The shadows cast by an object form just as much a part of the picture as the object itself. The dark areas of the objects within a still life are not merely that, for they tell us a great deal about the objects themselves. The chiaroscuro areas define textures and lights, both of the objects included in the still life itself and those that are reflected from a distance.

Common Features in Relief

The objects in a still life face a source of light that may be natural or artificial. This light source always travels in a straight line and, when it strikes a surface (the observer can see the reflected light), the intensity of the light will not change provided the object is directly facing the light and has a smooth texture and color.

If any of these factors is absent, the illuminated surface will no longer be uniform but will adapt itself to changes in contrast that can be caused by any alterations in light carried to the surface of the object.

In other words, a flat surface that receives a uniform light will change tone with the slightest variation in its plane.

Light and Volume

When light strikes an object, it produces a series of chromatic effects over its surface that in painting are represented by form and volume.

How much light the object reflects depends on its texture. Totally flat surfaces reflect the light sharply. When the surface is spherical (as opposed to flat), the intensity varies over the surface in such a way that the area closest to the light will be brighter and then become darker as the surface of the object recedes from the source of light.

One trick for separating the colors of the subject is by squinting as you look at it. In this way you lose definition of the forms, while finding it easier to capture their overall tonality.

Tonal Evaluation

To be able to use chiaroscuro in painting, first you must understand the tonal variations of color. The best way to achieve this is by first evaluating the grays. In this way, emphasis can be placed only on the changes in the position of the different planes of the object. From this you can see that, far from requiring an endless number of tones, tonal evaluation requires only a narrow range of tones to be effective. Only seven tones were necessary for the example below.

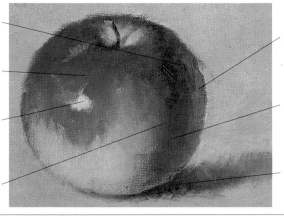

The "hump"; the darkest area of the shadow.

The subject's own color.

Highlight; maximal contrast produced by the light.

Shaded area; a color in the area between lights.

Reflected light; luminous reflections on the shadowed area on the edge of the shape.

Own shadow; the opposite parts to the illuminated half.

Shadow cast; usually darker than the area next to the object that casts it.

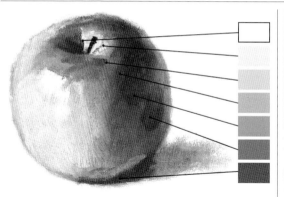

In order to understand the tonal evaluation of colors, you can always use a monochrome tonal scale.

A poor example.
Because of the close tonality,
contrast has been lost.

MORE INFORMATION

- Pastels. Value painting and colorism in still lifes **p. 50**
- Light and oils **p. 70**

Contrast

The tonal evaluation of the objects present in a still life has an absolute effect on the contrasts, i.e., the variety of lights on the different planes of the object's volume. This is why a lack of volume in an object you have painted or drawn makes it seem flat, two dimensional.

This tonal evaluation, however, should not be used to excess as this would destroy the contrast through a lack of tonal variety. Neither should the color white be used excessively, as this subtracts from the grays, creating a languid tone and clumsy volume. A well-contrasted object should relate

Incorrect understanding of tonal valuation. Immoderate use of white and excessive contrast.

Contrast and Unity

To apply contrast accurately to the different objects in the subject requires the right application of the chromatic range so that the hues of the lighter areas are also visible in the darker, more opaque areas.

This was how Jean-Baptiste Siméon Chardin (1699–1779) resolved his compositions. He would apply a base tone and use this to produce a chromatic harmony that blended the areas of light and shadow together.

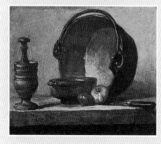

J.B. Chardin,
The Copper Pot.

to part of the background, not merely be superimposed, so that the lights on the surface will be in harmony. The areas falling into shadow should assist in defining the volume of the objects within the composition.

A correct interpretation of contrast.

THE COOL PALETTE

A chromatic range may contain an infinite number of color combinations.
However, the use of a given harmonic range, such as the cool range,
may create a center of interest in a painting consisting of an
otherwise warm field of color.
Working in a particular chromatic range does not depend upon the subject,
but upon the artist's chosen palette.

Colors

The colors within the cool range are greens and blues. However, when choosing cool colors for a still life, do not rule out the use of warm colors to counterbalance the overall tone.

An artist should realize that a cool color such as green, for example, can gradually take on warm hues on the palette by adding just a little yellow and then a tiny amount of ocher, all of which is then lightened to a yellow green by the use of a small amount of orange. These mixtures introduce a series of warm values to the colors of an otherwise cool palette.

The Subject

To paint a subject using a cool range of colors does not mean they need be the actual colors of the subject, yet it is much easier to handle the tones if you choose a subject with colors tending toward

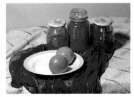

Here the subject is full of elements that have blue as the dominant color; the only warm touches take up the reflections of their surroundings.

those of the palette you have decided on.

There exists a harmony between the colors of a picture when the dominant light is reflected equally over all the elements of the subject, even though it may contain touches of a different chromatic range.

A subject with a cool tendency will also receive warm tones that are reflected from surrounding warm-colored elements.

Sketching and Roughing-out

When undertaking a painting with a mainly cool tendency, it is first necessary to make a color sketch of each area in as much detail as possible, so that when the initial painting is applied you will have a good guide for reference. This does not mean fully developing the sketch; just a color note painting in pastel or tempera, i.e., any fast medium that will provide a quick assessment of the color scheme.

Because the sketch will serve as your guide when it comes to the initial underpainting, it should be made in accordance with the color intended for each area. In the example below, blue has been chosen as the dominant color for the painting, except for the tablecloth and the oranges.

A sketch records the basic colors of the subject to be used as a guide when painting the picture.

De Chirico and the Cool Range

Many artists can be recognized by their use of a particular chromatic range, as they often use the same color range throughout their career. In this example, De Chirico (1888–1978) uses greens in a special way, balancing the composition with the addition of more luminous, warm colors.

Giorgio de Chirico, The Sacred Fish (fragment).

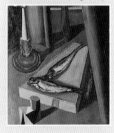

Composing the still life for this painting was carried out with a line drawing that persists throughout the entire work.

The initial painting will be done by areas. The tendency is cool, with warm tones scattered about.

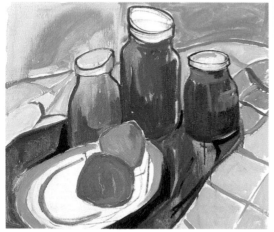

Continuity and Chromatic Unity

When the canvas has been initially painted, a chromaticism appears that will become the definitive factor throughout. A general color has already been mixed on the palette. This color is most useful for bringing other colors into harmony while adding touches of cool chromaticism to the areas that have been painted in warm colors.

Exchanging Values

Colors that are complementary to the cool range, i.e., warm colors, are greatly influenced by the dominant chromaticism.

The darkest areas of the shadows of orange are effected by small touches of blue, creating a greenish ocher. The oranges also produce a chromatic effect on the lightest areas of the picture, such as the plate or the shiny areas on the jars.

MORE INFORMATION

• Contrast **p. 38**
• The warm palette **p. 42**
• The neutral palette **p. 44**

Colors harmonized on the palette are used to bring out the tones of the new colors added subsequently, as well as to cover the surface of the shadowy areas in warm colors.

TECHNIQUE AND PRACTICE

THE WARM PALETTE

A successful chromatic range is achieved when all the areas of the picture
possess a common harmony. Harmony, in one sense, is the proper order of colors,
so when we refer to a chromatic range, especially a warm chromatic range,
our aim is to apply this esthetic order to the picture in order to produce a pleasing effect.
A warm palette creates the sensation of looking at the work through
warm-colored glasses.

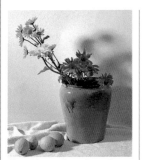

The subject we have chosen here has a pronounced warm tendency. The dominant color is an orangy yellow.

How to Compose the Subject

A still life is built up of simple elements combined in a well-balanced composition. A still life usually has an inherently warm chromaticism, which simplifies the task of harmonizing the colors on the palette. Nevertheless, it is a good idea to make a rough sketch to act as a guide before actually painting.

Using warm colors for painting a still life will often simplify matters as the colors

A preparatory sketch helps to synthesize the color.

fall into the same tonal scale. In addition, this provides the opportunity to later introduce complementary colors.

The Basis of the Painting

When using a particular chromatic range, many artists will cover the entire area of the painting with a general color similar to the anticipated dominant tone of the finished painting. This creates greater harmony between the colors and forms a common base for both opaque and transparent

The first layer of color brings that of the canvas closer to that of the still life. This uniform color is applied using a wide brush.

colors. This underlying color will, here and there, show through the opaque colors, lending uniformity to the atmosphere of the painting and the more transparent colors will blend more naturally into the composition overall.

MORE INFORMATION

• Contrast **p. 38**
• The cool palette **p. 40**
• The neutral palette **p. 44**

Mixing Colors

Always prepare beforehand on the palette the chromatic range (in this case, warm) you intend to use.

Thousands of combinations can be used to produce a warm harmony, though in this case we have used yellow, red, blue, and white. First, mix a little red into yellow to increase the "warmth" of the color; then make a slightly cooler yellow by adding a little blue; this mixture will produce a yellowish green. This paint can then be made more or less transparent by the addition of turpentine if using oils, or water if using watercolors.

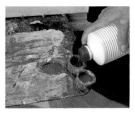

A little solvent can be poured into the palette cup to be used to obtain a more liquid paint, if necessary.

Orangy yellow, obtained by adding a touch of red to the yellow.

A cool yellow, obtained by adding a little blue.

Composing and Initial Painting

Once the canvas has been underpainted in yellow, tonal variations of yellow are added to create warmer planes, some with more red, others with more white. The subject is then outlined in dark purple using neat, unwavering lines, and completed by covering the areas in shadow with cool colors, such as bluish grays with a little crimson to add a touch of warmth.

Once the background has been resolved, the lighter area of the plant pot is painted in mostly orange, as are the

A Warm Style

Francesco Lazzaro Guardi (1712–1793), with his carefree style, presents us here with a complicated still life in which the dominant range is clearly warm. With his fluent, yet deliberate brushwork, he produces a series of different sensations of depth between the flowers, with sharp, dynamic expression in the foreground that fades slightly as it blends into the more earthy tone of the background.

Francesco Lazzaro Guardi, Still Life with Flowers.

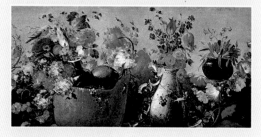

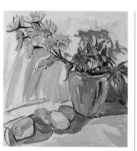

A quick, clear sketch in which the shadowed areas are painted in cool colors.

shadows of the lemons. These orange brushstrokes leave unpainted areas through which the yellow of the background is still visible.

Creating Tones

Over this background blue colored areas are painted that blend with the yellow to produce the shadows of the flowers, again adding a more orangy yellow to tone down the cool colors. New tones are obtained by blending colors directly on the canvas itself, although avoiding too rich a mixture.

Adding new tonalities increases the contrast between the shapes and the presence of warm colors. Last, the shadows of the background are resolved, leaving a small margin that outlines and emphasizes the flowers.

The volume of the brightest areas is painted using orangy colors, letting the background show through.
The flowers were painted in orange, pink, and violet.

TECHNIQUE AND PRACTICE

THE NEUTRAL PALETTE

The neutral palette is so called because the colors are mixed with their complements and would therefore be out of place in a picture employing only pure colors. Yet if the entire chromaticism of the painting is mixed, this creates harmony among all the colors used. Using a neutral palette in a still life produces a certain atmospheric effect, the planes become more distinct, and any pure color used in the painting will stand out due to the chromatic contrast.

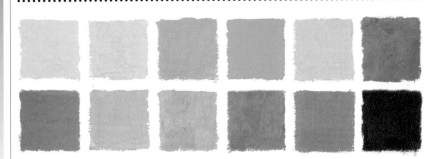

The range of neutral colors has a grayish appearance that results from adding a certain amount of white to the mixture.

Obtaining a Neutral Color

The range of neutral colors may provide an endless variety of color harmonies. Every color intervenes in this range, although not, of course, as a pure color. When mixed in unequal proportion, and pitting two complementary colors against each other plus adding a touch of white, we arrive at a color containing all three of the primaries. In order to obtain a neutral color, simply glance at the color wheel and choose one. The color opposite it in the wheel will be the one that "neutralizes" it. Do not mix these colors in exactly equal proportion; there must be a dominant color to which a little white has been added.

The base for the picture has been painted in a neutral color.

The Neutral Base and the Scheme

The best way to begin a still life that uses neutral or mixed colors, is to start with an initial application of color. In this case, a dark brown is rubbed onto the canvas with a rag. This underlying neutral color will

A few lines resolve the scheme for the still life.

harmonize with all subsequent layers of paint as they are added to the still life.

When it is dry, the initial sketch can be made by drawing or painting the lines of the intended composition. Here this stage has been done using a neutral blue, arranging the forms as simply as possible.

The Initial Stage

This base color will be a decisive factor for the later development of the work. It should always be allowed to show through any subsequent additions in order to lend unity and coherence to the work taken as a whole.

The initial colors cover large areas without concealing the brush lines.

The initial painting is completed; touches have been added to the lighter areas such as the highlight on the fruit.

MORE INFORMATION
- Contrast **p. 38**
- The cool palette **p. 40**
- The warm palette **p. 42**

Small amounts of a more pure color are applied over the underpainting with flat colors.

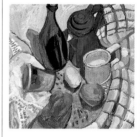

The neutral tone of the background still shows through the finished still life.

The first layers of color applied to the painting are those of the background and the coffee pot; a little yellow that is neutralized with blue for the background will absorb some of the neutral base color. The color for the coffee pot is dealt with similarly, by way of an earthy tone that alternates with the base color of the background. Note how the painted areas are contained within the drawing, without going over the lines.

Neutral Underpainting

We could say that this still life is distributed into zones and that each new color creates different values as it is added.

Detailed work does not form part of this initial painting, which involves filling in each defined area with neutral colors, breaking up the tonality,

and using the background as a color to be included in the painting.

Final Details

The underpainting of the picture produces an entirely flat, still life, lacking in detail. Using just a little paint and an almost dry brush, small, highlighting touches are added to lend volume to the objects and produce sharp contrast. These small dashes of color should be less mixed than the earlier colors used, although the background color should continue to appear through areas where the masses of color meet.

The whites surrounding the subject are added, allowing the underlying color to show through.

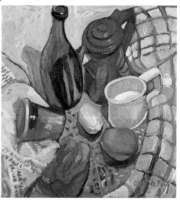

Cézanne and Neutral Colors

For this still life, Paul Cézanne (1839–1906) used a neutral palette, but with the difference that the white he would add was not pure; he used a transparent white with just a touch of red, thus preventing the colors from becoming pastel-like and creating an unusual light effect in the entire work.

Cézanne,
The Kitchen Table.

TECHNIQUE AND PRACTICE

A STUDY OF LIGHT
IN CHARCOAL

Charcoal is the classic drawing medium. To start with some simple lines and to develop them into a complex study of the illumination of the different elements contained in a still life is one of the most common exercises undertaken by artists. Charcoal was the first drawing medium ever to be used and it has never gone out of fashion. A still life executed in charcoal helps the artist to understand the forms and the contrasts within the subject, simplifying its future interpretation with another medium.

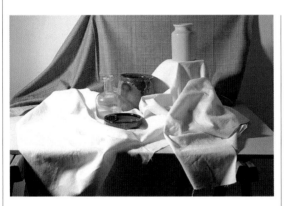

The lighting of a subject affects the composition, distributing the darker areas while contrasting them with the areas of maximal brilliance.

Subject and Lighting

The lighting of the subject is of great importance, irrespective of the technique you are going to use.

Basic to studying the lighting of the subject is that the composition of the objects be balanced. Further, the illuminated areas, as well as the shadows, must play a decisive role in developing the composition.

Lighting can be achieved with a single light source, remembering that the lower and closer it is to the subject, the sharper the contrast between shadows and lighted areas will become.

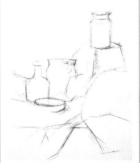

The initial drawing is done simply, guiding the lines with movements of the whole arm.

Scheme and Construction

In order to decide the scheme of the subject, it is important to make a simple drawing, positioning the different elements on the paper. The construction of the subject at this point lacks detail and is composed by virtually straight lines. To do this, the charcoal stick should be held flat between the index finger and thumb. The drawing is not controlled by turning the wrist, as in pencil drawing. Here the movement of the whole arm is used, while regularly checking the size and the proportion of the elements that compose the subject.

Detailed Areas

Once the elements of the still life have been correctly positioned, and any lines that may be out of place have been erased, the artist then approaches the areas of shadow and light.

The aim of this exercise is not to analyze the tonal variations but to distinguish which masses of color are to be used and which elements of the still life they are to represent. No detailed work is necessary at this point.

After studying the subject, the shadowed and lighted areas are then indicated.

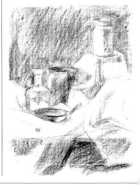

The Neutral Palette
A Study of Light in Charcoal
Pastels. An Introduction to Color

47

The darkest areas are resolved with quick, flat strokes, omitting the areas in which light is the main element.

Evaluation and Monochrome Work

Charcoal drawing exercises are basic to acquiring the skill to evaluate grays in monochrome work. By working continuously at monochrome studies in charcoal, the eye becomes accustomed to see colors as values, so when using a chromatically rich palette, the benefits of your charcoal studies will become apparent. It will also become much simpler to evaluate the colors and the differences and contrasts between them.

Stumping and Evaluating

All of the gray is stumped, not erased, by using the edge of the hand and the fingers in order to achieve middle values.

Gray is stumped with the hand. A uniform gray tonality now remains.

The darker areas take on a more definitive shape against the gray base color.

We have thus created a gray tonality in order to bring all of the values closer to those of the subject.

Evaluating consists of balancing the lighter and darker areas by increasing or reducing the contrast between them. In this way, each color of the subject is developed in a different tone of gray.

In practice, over an even gray background, the contrast of the darker areas is increased, adding details such as the fold of the tablecloth, using light and shadow rather than contour lines.

Modifying Tones and Balancing the Contrasts

Working in charcoal involves constant correction of the previous stages, using them to the artist's advantage to enhance the picture. The gray tone added earlier is again stumped, producing two distinct tonal variations that are well integrated and that create numerous shades of gray. More charcoal work is now applied to the picture at this stage to strengthen the outline of the forms and modify the tonal contrasts.

In this way, blending new tones with the background, and adding new shades of grays, the contrast between them is gradually balanced. Finally, several whites are opened up on the paper using a soft eraser.

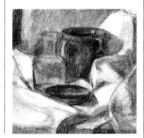

Correcting and evaluating must constantly alternate to produce more defined forms and tones of gray.

When the different grays of the still life have been evaluated, it is necessary to open up white areas with the eraser for the highlighted parts of the picture.

MORE INFORMATION

• A surface for oils, paper **p. 58**
• Light and oils **p. 70**

PASTELS. AN INTRODUCTION TO COLOR

Pastel is a direct, spontaneous medium that produces immediate results.
It is the pictorial technique that is closest to drawing. In its application,
it also allows the artist to deal with pictorial themes that no other technique can achieve.
With the use of only three tonalities we can paint a still life, using this technique
for synthesis and evaluation in the same way as in drawing.

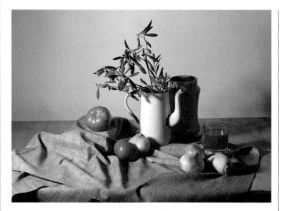

This still life is gently illuminated from the left.

Subject and Drawing

Pastels can be used to produce a picture in much the same way as a drawing and, like charcoal, the subject can be composed in the same manner.

The drawing has been influenced by the colored paper.

We have prepared a still life with side lighting in order to produce darker shadows. This will help you understand the effect of light on a still life.

Composing is accomplished with a sanguine colored pastel on light brown colored paper. Being able to work on a colored background enables you to use this color as if you were painting with it.

The drawing includes all the objects present in the subject. The shadows have been drawn in detail using hatching.

Introducing Color

Different planes are established within the drawing by gradation of the grays. In other words, the lightest objects are situated in the planes closer to the observer than those in shadow. The first note of color has been added to the tomatoes, which helps to create the sensation of depth in the painting. Over the application of grays applied with the black pastel, this addition of a warm color helps to break up the overall monochrome appearance of the work.

Evaluation of Tones Using Sanguine and White

The two tomatoes have been developed in sanguine, and

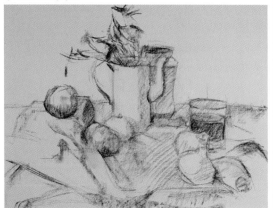

This first addition of color makes the background a chromatic part of the whole painting.

A Study of Light in Charcoal
Pastels. An Introduction to Color
Pastels. Value Painting and Colorism in Still Lifes
49

we can see part of the background color through the pastel strokes, especially in the lighter areas. If we wish to lend unity and coherence to the painting as a whole, this sanguine color should be present throughout the entire surface of the still life. Even without the addition of other colors, filling in the spaces with parallel hatching suggests the different planes and position of objects, such as the tablecloth. Now an overall tonality gradually begins to appear throughout the entire still life.

The warm tonality is present over the entire surface of the painting.

Two basic planes of depth have been established, the one indicated by the painted tomatoes and that of the remaining parts of the still life that continue to blend into the background. Introducing white will create a third plane that will lend the objects their definitive volume. These white touches are added to the most luminous areas, such as the body of the coffee pot or the highlights on the objects on the tablecloth.

Edgar Degas, The Bathtub, fragment.

Pastels and Degas

Edgar Degas (1834–1917) was a virtuoso in this technique. He barely mixed the color, as you can see in this work. The highlights on the objects were added when the objects were practically finished. These highlights and the texture of the other objects were achieved with vividly colored crayon strokes that contrast with the background.

White is used to highlight the more luminous areas.

Representing Space with Color

The same process of using color can be intensified, substituting the monochrome values for color values, thus bringing the different planes of depth closer with a more luminous, or darker, color, depending on the chromatic range you are following.

It is not advisable to mix pastel colors, as they always appear fresher and more spontaneous when applied individually to the paper. This technique allows you to alternate the drawing and painting requirements as you gradually develop the whole painting.

The painting incorporates color from each area of the work, including those sections of the background that will show through the later applications of color.

These highlights have been applied almost as if this were a drawing.

The colors can be blended by the eye, but never actually mixed. Mixing is not necessary as pastels offer a wide range of colors that can be applied directly to the paper.

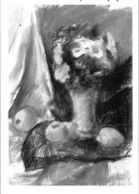

MORE INFORMATION

• Different mediums **p. 28**
• A quick technique **p. 36**
• Pastels. Value painting and colorism in still lifes **p. 50**

PASTELS. VALUE PAINTING AND COLORISM IN STILL LIFES

There are two basic ways of practicing painting. One is the traditional manner, inherited from past masters prior to Impressionism, with an emphasis on value painting; the other is colorism, which was introduced by the Impressionist painters. Either system can be used with any technique, although the use of pastels tends to direct the artist toward the Impressionist (colorist) tradition.

Value Painting and Colorism

In the opinion of value painters, the colors of the volumes are established by the contrast between light and dark, not via the color itself, which is achieved by mixing tones of different gradations of grays in order to obtain forms and shadows.

Colorism expresses contrast through colors, with no gradation of tone. In the colorist style, colors are applied directly, creating optical vibrations by placing complementary colors next to one another and creating depth through the use of receding cool colors in combination with advancing warm colors.

Composing in Value Painting

In value painting, volume is created from blending tones

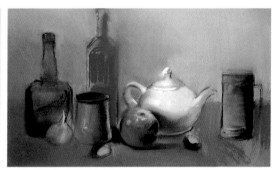

The aim of value painting is to create the volumes of chiaroscuro and to establish its tonal relationship with other objects.

and producing light and dark values that "model" the painting. This kind of work requires an overall tone that includes different tonal values depending on the position of the object with respect to the light.

Composing seeks to establish an understanding of the chiaroscuro of the various elements. Therefore, the underpainting should consist of a variety of values using the one overall tonality.

In the final painting it is important to understand that depth is usually achieved through value gradation rather than through contrasting colors.

Composing in Colorism

In colorism, pure colors are used that act as points of light as well as color.

Colors are not mixed but applied directly to the still life.

Objects are painted in colors often different from those of the actual elements in the still life.

Details are frequently kept to a minimum in order to emphasize the overall object as both a shape and a color mass.

In short, the intention of the colorist painter is to maximize the impact of color itself.

This initial painting includes an exploratory gradation of the tones.

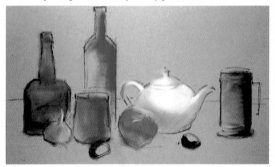

Pastels. An Introduction to Color
Pastels. Value Painting and Colorism in Still Lifes
Brushwork

51

Colorism and Audacity

The fauvists maintained a bold, colorist attitude that at the time was not accepted by a society used only to value painting.
The attitude of painters such as Gauguin at the end of the nineteenth century earned them the derogatory name of fauvists, meaning "wild beasts" in French.

Emil Noldé, Large Poppies.

A Colorist Finish

Once the canvas has been underpainted, certain tones can be blended in with freshly applied tones that create highlights and other contrasts. In any pictorial technique, colorism works by adding chromaticism that establishes planes in the painting.

Colorism always is more direct and specific in the foreground, i.e., in the still life attention is focused more on the foreground brilliance than on the background.

Development of Value Painting

When the still life has reached the stage at which the tonal values have been defined, the definitive tone is achieved by successive gradations of color that merge with those already in the painting. These additions of color in value painting involve blending them in with the other colors so that no layer of color stands out above the rest.

The paint develops the volume of the objects using the contrast of tones more than of color itself. In fact, the same effect could be produced in black and white without the picture losing any of its volume.

The colors begin to merge by means of the tonal contrast.

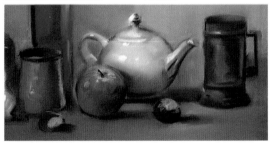

Relationship of tones is what lends unity and volume to the work as a whole.

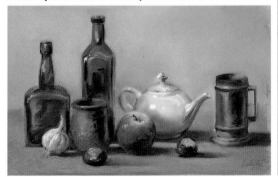

Different layers of color are applied, color taking precedence over volume.

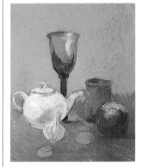

The colorist finish always produces a fresh, spontaneous effect, strong brilliance, and pure applications of color.

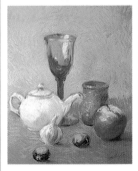

MORE INFORATION

• Watercolor. Colorism and value painting. Technical app. **p. 54**

BRUSHWORK

When you observe the subject carefully, you note that each of the objects
in the composition has a surface on which the light strikes, emphasizing those
sections that create the volume. In this way the light bathes the different elements and
separates the planes on which they are located. Representing the different planes
that separate each of the objects in the still life is done not only through the use of color
or tonal evaluation; the brushstrokes themselves create pictorial planes that
separate planes and light from shade.

Construction in Value Painting

In value painting, it is assumed that the volume of the objects is achieved by gradating the color of the objects with darker and lighter values that follow their surface planes in order to create the illusion of volume. In practice, this means that the brushstroke will always draw some of the actual (local) color of the object into the darker and lighter values that have defined the surface planes in order to create the illusion of volume. Brushwork in value painting should be gentle, blending areas and modeling the object in accordance with the plane on which it rests. In value painting, blending the colors on the palette and then applying them should be done in brushstrokes that imitate the planes of the objects themselves.

Construction in Colorism

The brushwork used in colorist painting assumes that the color of the darkest areas does not necessarily create volume, and seeks to present the actual, unshaded, color of the object. The brushwork reflects color-light, not color-shadow. This kind of brushwork is free and full of paint, and the brush is never dragged across the surface. It is the volume of the paint itself that creates the planes of each of the elements in the still life. Colorist brushwork can,

Colorist brushwork does not include blending the colors, but applying paint directly and building chromatic effects through contrast.

The planes in the picture need not be constructed by the direction of the brushstroke, but by the colors themselves.

In value painting, the brushstroke carries the paint into adjoining colors, following the plane of the object.

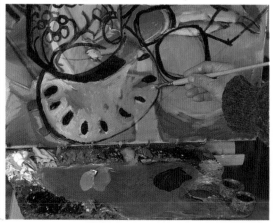

Pastels. Value Painting and Colorism in Still Lifes

Brushwork

Watercolor. Colorism and Value Painting

53

however, be applied as an underpainting or final coat, superimposing layers of color on wet or on dry.

Effect of Brushwork in Oils

Oils can produce a wide variety of plastic expression with just the effective use of the brush. Given the covering power of this medium, different textures can be achieved without adding anything to the paint. When only a little paint is used, a *frottage* can be applied to reveal part of the underlying colors. Another type of brushstroke is used for glazes, applying a highly diluted translucent layer of color over a dry base. Blending results from the gradation of one color into another; this brushstroke

The frottage *technique.*

Applying a glaze to a dry surface.

Blending colors with the brushstroke.

is directional, gently drawing some of the paint of one color into another.

Brushwork on Wet and on Dry

Watercolors can be used in one of two ways: brushwork applied onto a wet background, so that the color tends to spread over the damp area; and brushwork on a dry surface, which is similar in practice to the *frottage* technique in oils, but with the difference that it produces the same effect by using a transparent medium.

Types of brushwork suitable for watercolors. Using just a little paint on the brush on a dry background produces the frottage *effect. If, however, the surface is dampened, the color will spread.*

Van Gogh's Brushwork

The work of Vincent Van Gogh (1853–1890) is characterized by its considerable expressiveness; the brushstrokes flow to build up the forms. Detailed brushwork is taken almost to an extreme as he alternates between thin-painting and impasto-painting.

Vincent Van Gogh, The Sunflowers.

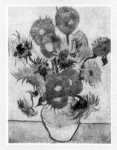

Planes and the Palette Knife

A palette knife can be used to construct planes both by dragging and blending the paint and by applying thick impastos. The edge of the knife can be used to draw some of the paint toward the other colors which will then merge together. Different forms and gradations can be obtained by this method.

The palette knife enables you to produce a uniform, directional blend of colors.

TECHNIQUE AND PRACTICE

WATERCOLOR. COLORISM AND VALUE PAINTING. TECHNICAL APPLICATIONS

Colorism and value painting are two pictorial concepts that differ in their interpretation of reality. On the one hand, value painting would represent a still life in which the colors are gradated or organized to create the effect of the volume of the objects, while colorism understands that the shadows of the elements of a picture act and should be considered as having their own colors. Watercolor is different from other techniques in that it is transparent and its luminosity depends on this transparency. This is a characteristic that should be borne in mind whichever style, technique, or color is used.

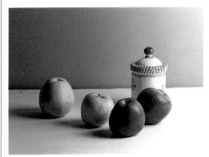

A still life for value painting a watercolor.

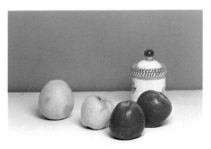

A still life for painting a colorist watercolor.

The Subject for Value and Colorist Painting

Watercolor might well be considered the most delicate of pictorial techniques. Unlike any other medium, it requires each stage of its development to be "definitive" in the sense that it cannot be corrected later on. This characteristic of watercolor means that great care must be taken when choosing the subject. If the approach is to be that of a value painter, an emphasis on contrast and tonal gradations is advisable, as in using a gentle side lighting to reveal brilliant, luminous colors on one side in contrast to the area in shadow.

A subject that is to be interpreted in the colorist style requires emphasis to be placed on the actual "local" color of the objects; the best lighting for this would be from the front, thus eliminating most gradations.

Differences in the Initial Painting

One point that all these chromatic approaches agree on is the necessity of an initial sketch. Watercolor requires a

Value painting stresses the areas of light and shadow.

Shadows are eliminated from this colorist approach, while stressing the local color of the objects.

well-defined sketch, with no superfluous lines that may cause confusion later. The initial color in value painting is effected right from the beginning by the way it influences the tones in the theme, locating the brightest and the darkest areas of each object in advance. When painting the background, the objects that are to remain in the foreground are outlined, left to dry, and the remaining elements in the still life are then added. This is done first by emphasizing the darkest areas and gradating the color toward the areas of light.

Colorist underpainting starts with pure colors and no shadows, leaving only the areas of maximal brilliance.

MORE INFORMATION

- Pastels. Value painting and colorism in still lifes **p. 50**
- Painting in watercolor **p. 82**

Brushwork
Watercolor. Colorism and Value Painting
A Quick Sketch in Wax Crayon

55

Realism and Watercolor

In value painting, the fully developed subject can be seen from a highly realist, almost photographic point of view.

In this work by Josep Roca-Sastre (1928) you can see how the application of tones can be used as a creative tool.

The light is employed in masterly fashion, and, since white has not been used, the lightest color visible is that of the paper itself.

Josep Roca-Sastre, Mosaic.

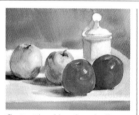

Contrast is achieved gradually, modeling the forms with dark and violet tones, together with the long shadows on the table.

The colors are applied directly, hardly defining the forms of the subject and with little tonal contrast.

When developing a colorist work, the colors are applied in almost pure form, slightly blending in the warm and cool colors of the background (see above, right). The forms are barely modeled and are defined by small intense touches of color.

The Final Stage

Finish, in value painting, involves constantly reworking the tones and, in the case of watercolor, this naturally requires being careful with the more intense areas that need blending by means of successive glazes of a darker color. In order to maintain the purity of these areas, the darker masses of color require gradating. In the same way that the tones of the fruit were gradated, the volume of the white ceramic jar is emphasized by applying and gradating a violet glaze.

In a colorist finish, what really counts is the impression it creates; a light, very clear ocher glaze will lend unity to the different elements of the painting.

Defining the Color

A watercolor may develop in different ways once it has been started, because the earlier brushwork will still be visible due to the transparency of the medium. In value painting, the chiaroscuro effects are emphasized, darkening the shadows of the different objects and increasing the contrast with dark glazes. In the example shown above, left, the shadows have been resolved with a bluish violet tone that generates a strong contrast with the pure, more luminous colors applied earlier.

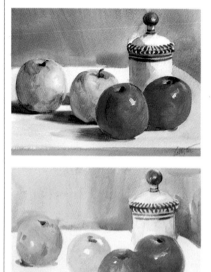

The finish of a watercolor in value painting tends to increase the darker areas and leave the lighter ones to emphasize the contrast.

A watercolor in the colorist style does not require much elaboration; simply a light glaze to bring the painting together.

A QUICK SKETCH IN WAX CRAYON

A still life can be composed in an endless number of ways. It is one of the
pictorial genres that include the most complete exercises in light and composition.
Before starting to paint, it is always advisable to make sketches, on any kind of surface,
that will act as a guideline later on for the forms, masses of color,
or simply in order to study the composition.
Colored wax crayon is perfect for quick painting as it is luminous and
provides instant results.

Types of Paper

Still lifes are a pictorial genre with a marvelous potential for all kinds of work on paper. It depends, however, on the technique you are using, whether you choose heavy paper or something like delicate rice paper. Wax crayon is a medium that can be used on practically any kind of paper, provided no oil solvents are used as that would require a fuller-bodied paper.

Composing and Initial Painting

Although wax crayon painting is an opaque medium, it demands a careful approach because it covers in the same way as pastels. As wax crayon does not totally cover the surface but allows the background color to show through,

The drawing is superimposed on the earlier layers of color. The background is visible through the lines.

it is advisable that the initial forms be well defined in order to avoid any doubts when painting. Application is more like drawing than painting, using the pure colors in a gentle manner in order to

The first colors to be applied are soft and do not entirely cover the paper.

provide a workable base for the further applications of color.

Over the initial painting the masses of color have been quickly outlined.

Tones and the Development of Color

Continuing from the gentle initial application, tones are added to darken and define elements. For example, if the grapes have been painted first in blue, the color will be defined by an overlayer of

The shadows of the grapes are emphasized with a little crimson.

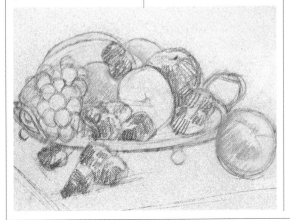

MORE INFORMATION
• Priorities. Drawing or painting **p. 90**
• Combined techniques **p. 92**

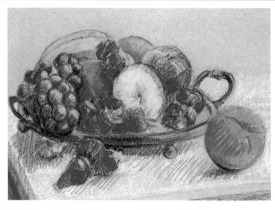

Despite having applied large amounts of paint, the underlying color continues to be visible.

crimson in the areas in shadow. The background colors of the paper then appear as a luminous tone, as it is the lightest tone visible throughout the composition.

Over the light pale base, stronger, more luminous colors are added, which actually cover the paper in areas where more intense colors are called for. The white wax crayon helps to soften the contrast and is always the last color to be added, strengthening the highlights and the areas where the shadows need softening.

The Compatibility of Wax

Wax can be used for many purposes because, although it appears to be solid, it dissolves easily in turpentine. This makes it especially compatible with oils and it can be used as a base color for an oil painting or actually mixed with the medium itself. Mixing oil with a small amount of wax dissolved in oil and warm turpentine lends this medium a velvety appearance that tones down any excess gloss.

A Negative Image

Wax repels water, and this can be turned to the artist's advantage when painting a watercolor, since both wax and watercolor have one element in common: they depend on paper.

Here, the areas that are to be the brightest in the finished work are isolated using wax. The picture is constructed without entirely covering the paper.

After drawing the subject correctly, the brightest spots are applied in white.

This technique causes any area not covered by wax to absorb the watercolor into the paper.

Applications

This is a mixed technique of watercolors and wax.

Once the wax has been applied, ink and watercolors follow in several washes. These washes, however, are repelled by the waxed areas and the only places where color can be seen are the wax-free places.

The proper application of the watercolors is just as important as the work in wax. This creates large, contrasting areas producing a patterned effect.

The brush draws the paint across the paper, but the paint is repelled by the waxed areas.

This composition leaves many open areas that have been lightly drawn in wax.

A SURFACE FOR OILS, PAPER

When oils are mentioned, we tend to think of canvas or some other rigid support. However, paper can be used for oil paint just as successfully as the best canvas. However, the method of work may vary considerably.
There exists a long tradition of painting in oils on canvas, and most artists have chosen this material for their works. Yet there is a large number of painters who have chosen paper as a surface for their oil paintings.

Preparatory Drawing

Paper is an excellent surface for drawing and painting, as it allows the work to be corrected as you proceed. The way the subject is drawn depends on the degree of realism desired, but it should always be a clear, neat drawing such as those used to prepare for watercolor painting. Working in oils on paper is different than on any other surface in that paper does

The drawing should be clear and concise, gently defining the forms.

Turpentine combines the graphite with the fiber of the paper, so that it cannot be erased.

not allow a heavy impasto painting, so the layers of color should be thin and often translucent. The drawing should therefore be concise, developing the forms of the volumes, although not the tonal evaluation. This approach will be appreciated once the drawing has been completed. Begin by

introducing gentle grays and then sharper contrasts, which are achieved by using pure graphite. Lastly, the surface is painted using the brush and turpentine to blend and gradate the tones.

Priming the Surface

Oil is a medium that adapts to any surface. If it is of organic origin like fabric or paper, it requires priming. There are two reasons for this: first, so that it does not absorb the oil in the medium and thus dry the paint, and secondly, so that the fibers do not begin to rot on absorbing the oil. There are many ways of priming paper. The quickest is to spray on several layers of fixative that will form a protective film and prevent the drawing from mixing with the oil paints.

Once fixative has been applied to the drawing, it is then primed again, but with turpentine so that the oil will flow over the surface of the paper like watercolors.

Applying fixative does not mean that once it is dry, you cannot prime over it again. This fixative will penetrate the paper, dampening it and enabling the artist to work with a highly liquid form of oil, almost like using watercolors.

The First Color

After the paper is primed with fixative, the application of turpentine will allow the oil to flow, without mixing with the graphite. Using a transparent glaze of color highly diluted by turpentine, the foreground of the painting can be quickly realized, diluting the paint more for the more luminous areas and reserving those areas where the white of the paper should show through. Because the drawing and underpainting contain a good amount of development, the almost transparent layers of color will blend together.

The first layers of color are added in the form of transparent glazes.

The colors are developed by adding warmer tones to the monochrome work. The highlighted areas of the picture should be left untouched.

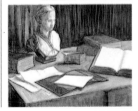

Priming the Paper

Paper is, at the same time, one of the most resistant yet delicate working surfaces. Paper is made of vegetable fibers and glue; if the amount of glue is insufficient, humidity can deteriorate it over time. If, on the other hand, the paper is well primed, it will become more resistant to both paint and humidity.

Whenever you are going to paint in oil on paper, it is advisable to protect the fibers from direct contact with the medium. A quick way of priming the surface of the paper is to rub a piece of garlic on the edges of the paper you are going to paint on.

Adjusting the Tones and the Color

A well-primed piece of paper allows the artist to constantly remodel the colors without fear that the underlying drawing will be erased. As the oils used at this stage are highly diluted with turpentine, they can be repainted at a later stage with undiluted colors. Here, a limited palette is used to simplify the composition and the colors are mixed somewhat together so that they all have an earthy, reddish tendency.

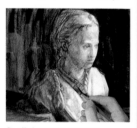

Small chromatic variations within the range of ochers accentuates the contrast between the different objects.

The Last Layer Is the Thickest

As the artist approaches the end of the painting, different layers of more dense colors can be applied, using the light colors of the background in the open spaces that will become the highlights in the finished painting.

This oil base makes it easier to do blends and tonal gradations. Transparent work can be alternated with more opaque applications that actually give a three-dimentional effect to the subject.

The palette is limited, but can still produce a wide variety of tones.

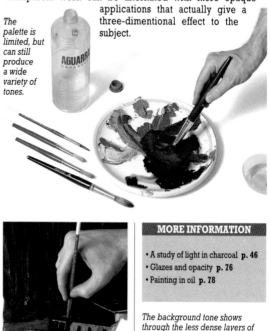

MORE INFORMATION

• A study of light in charcoal **p. 46**
• Glazes and opacity **p. 76**
• Painting in oil **p. 78**

The background tone shows through the less dense layers of paint in the form of points of light.

Blending the final brushstrokes with the background color brings out the texture of the different objects in the still life.

IMPASTOS IN STILL LIFES IN OILS

Oils are a full-bodied medium and require no further additional materials
for creating texture. They can also be used in a totally transparent form
depending on the amount of turpentine or linseed oil that is added.

Basic Rules

The basic technique for any pictorial medium is to observe the rule of thick over thin. Oils are a fatty medium that use turpentine as a solvent. This means that whenever you are painting impastos over a layer of oil paint, these must be thicker than the underlying layer. The solution to this is easy; the first layers applied to the canvas should have a larger amount of turpentine so that, as you paint, the amount of solvent diminishes until no trace of turpentine can be seen in the final result. In this way the painting will dry gradually without any risk of the paint "peeling."

Deciding on the Theme

A still life painted with impastos should be well constructed, though concise. It should suggest only the definition of the larger volumes and the areas of major tonal variations.

A quick, monochrome, highly diluted work.

Composing the theme involves distributing the volumes, not defining the forms, as these will be gradually developed as the still life progresses. The painting can be started with slightly colored turpentine, dragging the brush along, rather than painting with it.

The First Layer

When artists intend to use thick impastos, they must begin the underpainting by using a good amount of turpentine to avoid any impastos forming at this stage. Other-

Vertical brushwork.

wise, they may cause difficulties later on. The color is prepared on the palette and should be fairly dense so as not to lose its covering power; it is then applied to the entire surface of the canvas, with wide, directional brushstrokes.

For example, when painting a tablecloth, the brushstrokes suggest the way the cloth falls. Objects with a curved surface are painted on the areas in shadow with a dark tone, although not so much so as to form an impasto.

Painting the background with just a little paint diluted with oil.

Applying a thicker layer of paint on the most intense area of the lemon.

Impastos

Once the entire surface of the painting has been covered with a thin layer of oils, the first impastos can be added. Although you may start at any point, allow intuition to guide you. Once the technique is learned, personal preferences must come into play.

Here the artist has started with the objects in the foreground, applying a heavy layer of color to the whitest part of the bowl. The brush is heavily loaded with paint, adding texture at the same time.

Impastos help to synthesize the forms. However, when working with thick paint, it

becomes difficult to produce detailed work.

As the picture progresses, less and less turpentine is used, so the brushstrokes become drier, and the palette knife comes into play.

Turpentine is used less and less as the still life progresses.

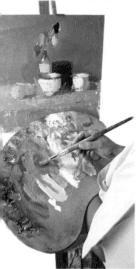

The Palette Knife and the Impasto

The palette knife was not used until the nineteenth century. The palette knife came to be used as a valuable tool with the arrival of the Impressionists and their new techniques. It is an important instrument for creating impastos, pointillism, or textured painting. Nowadays it is commonly used and has become one of the artist's most valuable tools.

Finishing an Impasto Work

The impasto work now covers the entire painting. This has prevented the inclusion of detail, so any additions are left to the final stage. Details are added to the large masses of color such as the flower, for example, or the tonal hues of the darker jar by using a finer

MORE INFORMATION
• Light and oils **p. 70**
• Painting in oil **p. 78**

brush, without mixing the colors beforehand and letting them act as fresh impastos.

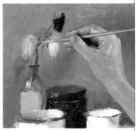

Tonal hues are added to finish the painting.

The more delicate areas are completed using a finer brush.

Applying a thick, grayish brushstroke.

The palette knife is used to level certain heavily painted areas.

Final appearance of a still life using impastos.

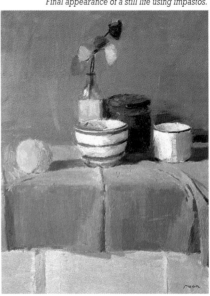

A TRANSPARENT TECHNIQUE USING TWO COLORS

Watercolor, in the hands of a professional, has terrific chromatic potential, to the extent that an entire chromatic range can even be produced using just two colors.
There are three basic aspects to consider when painting in watercolors: the transparency, the intensity of the tones, and the combining of the mixtures. A wide chromatic range can be obtained from these tonal variations.

Subject and Composition

Watercolors usually are applied from a light color toward a darker one, as this allows the two tones to merge, while alternating the quantities of each color, to produce washes of varying intensity. Two base colors

A wide chromatic range can be obtained from just two colors.

are used, for example burnt crimson and viridian green, two near-complementary colors that when mixed produce a dark brown.

The background is now undertaken, leaving till later the spaces for the different objects in the still life. This first tonality is achieved with a mixture that consists of a large amount of water with some crimson mixed in that will produce a grayish color that is applied in vertical brushstrokes.

A watery, brownish tone is used for the background and left to dry before adding other tonalities to the other objects.

Superimposing

The process of superimposing and mixing the tones appears rather complicated at first sight. It is all a matter of practice and knowing when a layer of paint should be left to dry before proceeding. This can produce many combinations of superimposed color that can range from a warm dominant color of earth hues to a cool dominant color with a glaze using its complementary color.

Chromatic Variations

Although the tones and colors that can be obtained using two colors (as well as their applications) are endless, even this can be increased by the play of simultaneous contrast (a lighter color is much

The mixture of two colors creates a wide variety of tones which can be widely varied because of their transparent nature.

more luminous if it is situated next to a darker color, and a darker color will appear darker if placed next to a lighter one). This is also true when placing two complementary colors next to each other.

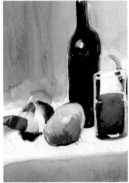

Strong lights and dark shadows can be obtained by using simultaneous contrasts and complementary contrasts.

Modeling the Forms and the Highlights

The diversity of forms in a still life can be created by the texture of the objects. Glass tends to glitter and thus alter the tone of its contents. In other words, a liquid such as wine vinegar, which has a reddish color, will take on a brownish tonality if the glass container is green.

Darker colors are used to emphasize the darker reflections while white is used for the brightest reflections of light. These objects are modeled by arranging the tones and sharp contrasts within the same color.

Introducing darker tonalities serves to create intense highlights.

A Color Filter

Watercolors act as a transparent filter, as if it were tinted glass, using just the three primary colors and then superimposing them. This superimposing creates new colors.

The volumes and highlights are obtained from whites and colored washes.

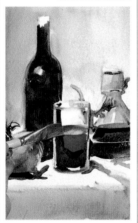

Finishing Glaze

Once the different color bases and tonal hues have been established, a brown glaze will be used to achieve the definitive contrasts and unity of the overall tonality.

Based on the area to be enhanced, the same glaze is applied either in a gradated or a concentrated way. The transparency of the glaze serves a double purpose: to emphasize those tonalities that should be darker and to highlight the textures of some objects; for example, the onions and the front of the tablecloth.

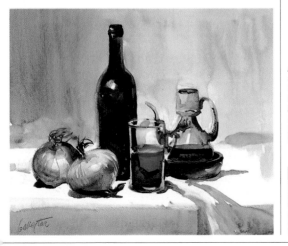

As a final touch, a glaze brings tonal unity to the work, while leaving certain spaces untouched in order to reveal earlier glazes of the complementary color.

MORE INFORMATION

• Watercolor. Colorism and value painting. Technical applications **p. 54**
• Painting in watercolor **p. 82**

ALTERNATIVE TECHNIQUES. TEMPERA

Artists today use classical techniques that in their time were considered revolutionary, such as oils or watercolor. The introduction of these new pictorial mediums pushed to one side other mediums that had been traditionally used for centuries. The reason for this was the plastic potential of the new mediums. Tempera, however, offers a different chromaticism and other qualities that are well worth resurrecting.

After placing the egg and the varnish in the bottle, it is beaten thoroughly and can then be mixed with the pigment to form tempera.

Tempera

Tempera was traditionally made with pigment, water, and egg yolk to bind them, while some artists preferred to also add a little varnish.

The medium is the liquid that carries the pigment and provides stability once it has dried. This medium of egg tempera is very simple to prepare.

After making the tempera it is advisable to keep it in a hermetic container so that it does not spoil. All you need to make it is an egg, varnish, and pigment. After beating the egg, it is placed in a bottle and the same amount of varnish as egg is then added; it is beaten again and mixed with the pigment on a glass or plastic surface.

If varnish is added, the solvent to use is turpentine.

In the drawing stage you can experiment with various compositions.

The Initial Drawing

Tempera is more opaque than watercolor. However, some varnish can be added as desired; this helps to lend consistency to the glaze, making it more transparent. The drawing should be as concise as possible, and therefore it is advisable to make a prior sketch and then transfer it onto the board you have prepared for painting the still life. This initial drawing can be done with a pencil and, when the entire composition has been realized, it is then transferred to the board. Just cover a piece of wrapping or tracing paper with pastels or colored chalk, place it face down on the working surface, place the drawing on top of it, and go over all the lines again with a pencil.

The chalked side of the paper is placed on the board; then the original lines are gone over, in order to transfer to the working surface.

A Transparent Technique Using Two Colors
Alternative Techniques. Tempera
Volume and Color Using Colored Pencils

65

A Technique in Evolution

Tempera, as such, is not commonly marketed nowadays, although you can find other paints that have derived from this ancient medium such as gouache.

Base Colors

Tempera is an almost transparent technique, so it is advisable, as in watercolors, to paint the lightest colors first. Begin by painting around the outline of the drawing in a light blue, which will be almost entirely covered by the subsequent colors. Tempera dries quickly, so the background colors can be added almost at once, filling in the areas carefully, without invading any of the other colored areas.

After painting the outline of the subject, several cool tones have been added.

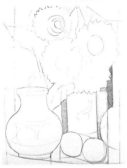

Working outside the subject, the background is painted in tonal areas using flat colors.

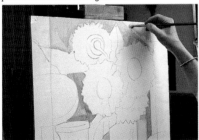

Intensifying the Tones

Tempera lends itself to glazes of flat colors, so it is a good idea to take advantage of this property by adding layers of tonality where desired. In this way, each of the areas of

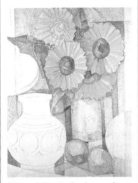

After painting the background, very transparent layers of tempera are added, suggesting the base color and avoiding the areas intended to be the brightest or most luminous.

color is built up independently of one another. Once the background is finished, the nearer planes are painted, first in a light, almost transparent tone, limiting each color to its particular area.

The final touches: painting the outlines and the darker areas.

Finishing a Tempera Painting

Now that each area has its definitive color, the areas intended for the shadows are painted. To produce transparent effects, use a sponge dampened in tempera with more medium than usual.

Successive layers of color are applied to this underlying tone, waiting each time for the previous layer to dry.

The last stage is to carefully paint the decorations and the final details, defining shadows and moderating any tonalities that were too light.

MORE INFORMATION
• Watercolor and gouache **p. 84**
• The opaque medium **p. 86**
• Combined techniques **p. 92**

A dotted effect can be achieved using a sponge dipped in the paint and applied lightly.

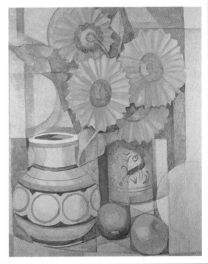

VOLUME AND COLOR USING COLORED PENCILS

Colored pencils are one of the first ways most people come into contact with painting.
Few people, however, know how to apply this technique effectively.
In order to paint a still life, the subject should first be studied,
as should the relationship between the forms and the effect of
light on the different objects.
Colored pencils help the artist to understand tonal principles and how to
create planes and also apply this knowledge to other mediums.

Two different forms of colors, in sticks and in a box of water-soluble pencils.

are introduced to suggest the volume and the mixtures of color in the painting.

Colored sticks can be used for painting large areas when used flat, or for drawing lines when using the tip.

After applying water-soluble pencils to the composition, a wet brush can then be used to blend the pencil lines into areas of color.

Different Forms

Painting with colored pencils is one of the most immediate pictorial techniques available. It is quick, clean, and each stage of its development is definitive.

There are a wide variety of styles and makes of colored pencils, as well as different tones and colors, all of which work together perfectly well.

Within the different kinds, there are three main ranges; the school grade quality, the professional grade, which also covers water-soluble pencils, and colored sticks.

Colored pencils cover a wide chromatic and tonal range.

Techniques

Pencil is an instant medium when used for drawing, and in painting is applied in the same way. When it is mixed or diluted with water, though, the technique is more similar to watercolor.

Water-soluble colored pencils are the most commonly used by artists working in this medium, which ceases to be a drawing medium when colors

The soluble pencil stain is merged on the paper using a damp brush.

Paper

The paper to use varies with the technique you are going to employ. Like all other pictorial materials, both wet and dry, the grain, or texture, of the paper decides the precision of the painted forms.

The weight of the paper is chosen according to whether you are going to paint in a wet

Gradated effect on fine paper.

Gradated effect on medium grain paper.

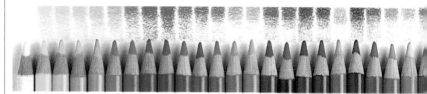

or dry technique. If you are going to dampen the paper, it is advisable to use a heavy watercolor paper.

The technique for colored pencils, as with watercolors, is transparent and therefore leaves the underlying layers of color visible. Colored paper can be used, as it will provide the base color that will influence all the other colors added during the development of the painting.

Gradated effect on heavy grain paper.

The Still Life

In order to focus on the technique used for colored pencils, we have chosen a simple subject, several basic geometric shapes in primary colors.

Each form has been rendered in perspective, the darkest areas having been outlined with the pencils. The approach to follow is always from light to dark. Each object casts a shadow plus a reflection on another object, changing its color. This is why the shadowed areas gradually take on the color of the reflected object.

This simple still life is composed of geometric forms.

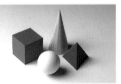

Once the elements have been established, the shadows are added along the direction of the plane on which the objects rest.

The colors are reinforced, defining the areas of shadow in gently reflected colors.

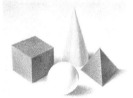

Highlights and Reflections

As the painting progresses, the colors added are increasingly pure.

The pencil is lightly applied, letting the underlying colors show through.

The areas reserved for the point of maximal brilliance should be left unpainted.

The technique of colored pencils constantly changes the various relationships of color contrast. For example, the visible edge of the pyramid appears much more luminous because the area next to it is much darker.

The colors have been intensified by increasing the contrast in the areas of light and shadow.

Contemporary Art and Colored Pencils

Many artists have used colored pencil as one of their means of expression.

This is the case with David Hockney, who has developed his own technique using this medium. In this still life, he has used large planes of very pure colors, experimenting with the areas left in reserve for the whites in contrast to the darker areas, while superimposing color over the lighter areas at the same time.

David Hockney, Still life.

MORE INFORMATION
- Different mediums **p. 28**
- The still life and water-soluble colored pencils **p. 68**

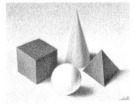

TECHNIQUE AND PRACTICE

THE STILL LIFE AND WATER-SOLUBLE COLORED PENCILS

Colored pencils are popular among painters due to their fresh and direct characteristics.
They are employed in much the same way as watercolors, meaning that light colors
cannot be painted over dark colors, for the same reason that it is necessary to develop
light tonalities before applying dark tones.

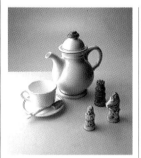

The subject has been situated so that the light envelops the objects, producing a soft shadow on the right-hand side of the painting.

Transparent Drawing

You must first study the subject before you attempt to compose and frame it within a

A precise drawing is fundamental for effectively resolving the painting. Violet was chosen here because this tone can be harmonized with the rest of the colors.

space. Once the lighting and the relationship of dimensions and proportions have been analyzed, you can begin to draw each one of the still life's objects. The drawing must clearly define the shapes of the objects, so that if some objects are too complicated to draw on the working surface, you can draw them separately and then trace them onto the surface you are going to paint on.

Water-soluble colored pencils allow you to blend colors and tones together. Here we have chosen violet because it blends well with both warm and cool colors.

Initial Application

After the initial drawing, a general base color that timidly relates to that of the final color scheme is applied.

The colored pencils should be applied to the paper gently, without filling in the pores, and leaving only a faint amount of color. During a later stage the work with colored pencils becomes more precise, stressing outlines and shapes.

The areas of maximal highlights are left intact, increasing the contrast with gray colors in the lower half of the teapot and in the chess pieces.

The development of tones is carried out gradually by gently applying the color while leaving the lighter tones to the last.

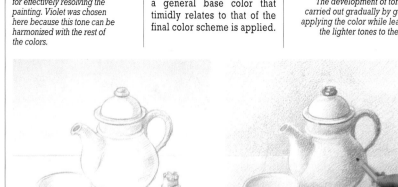

Heightening Contrasts and Blending with a Brush

The color is established with direct mixes on the canvas, intensifying the contrast with the use of grays and blues over the warm color base.

The added colors give way to the definitive chromatic intonation that gradually approximates the tones of the subject.

With a thick brush and plenty of water we paint the background.

Once all the colors applied with the water-soluble pencils are in place, you can blend them by wetting the areas concerned with a brush. You should begin by wetting the background from left to right with a lot of water and a wide brush.

Wet colors become saturated, increasing the tone of the color applied.

Colors blend together when wetted, heightening the dark tones and, by contrast, the areas reserved for the highlights.

From Less to More

Since with colored pencils a light color cannot cover a dark one, the color should be applied in a logical tonal order. The lightest and most luminous tones should be painted first followed by the more opaque and darker ones.

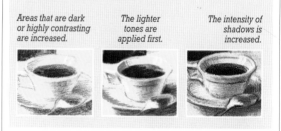

Areas that are dark or highly contrasting are increased.

The lighter tones are applied first.

The intensity of shadows is increased.

When a color gets wet, the tone increases, allowing the artist to take advantage of numerous wash effects.

The Watercolorist's Craft

The procedure explained here is basically just another way to paint still lifes in watercolor. Therefore, before starting with the color, you should first study the lighting carefully in order to determine the lighter areas that have to be held in reserve, just like in a watercolor painting.

MORE INFORMATION

- Watercolor. Colorism and value painting. Technical app. **p. 54**
- Volume and color using colored pencils **p. 66**
- Glazes and opacities **p. 76**

Once the drawing has been finished, the watercolor application will turn it into a painting. The initial development was done in pencil and is now repeated with a brush, blending and mixing the colors.

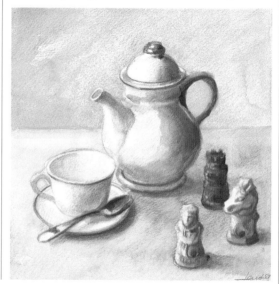

TECHNIQUE AND PRACTICE

LIGHT AND OILS

Each one of the still life's different elements has an independent relationship with the light that surrounds it, depending on its shape, color, and distance from the light source. These factors define the values. Unlike other mediums, oil paint allows for a continuous correcting of the painting's values, even when they have become obscured during the developmental process. Therefore with oil we can carry out an in-depth study of light with the possibility of making continuous changes.

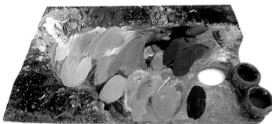

There is no such thing as a "light" color. Colors are paler where there exists a tonal contrast.

Volume Through Light

Objects are best studied under lateral lighting conditions. This allows us to establish the sharp contrasts produced by the planes of light and shadows.

The light on different objects is represented by means of the simultaneous contrast of two tones.

Oil permits the painter to paint the subtle variations that model the objects in the picture. In watercolor the artist has to work from more to less. However, the order of working in oil does not matter given the opaque nature of the medium. For example, with oil paint one can apply light tones over dark while developing highlights, thus giving form to the objects. This is another example of the importance of contrast in painting.

Contrast on Curved Surfaces

The surface of a curved volume is painted by outlining its geometric form with a dark tone, and shading the area in shadow.

Whether it be conical or tubular, this shadow area is vertically directed, because the light that reaches the objects helps to bring out their verticality.

Likewise, when the light reaches the interior of a hollow tubular object, it produces two areas of intense contrast. The darkest part should be painted first, following the shape of the curve's shadow.

The shadow area of a tubular objects is painted by following the verticality of the shape.

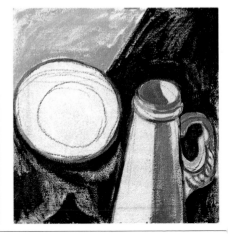

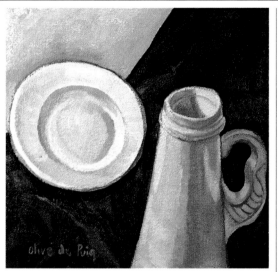

The different color areas that are applied to an object help to model it and the areas of light that indicate the volume and the direction of the light.

Light on the Folds and Creases of Drapery

In the same way that light brings out the volume of the objects of a still life, when you include drapery in the theme, different areas of chiaroscuro are produced by the creases. Even though the oil medium allows the artist to remodel, when you are dealing with something as complicated as this, it is important to draw several studies of the forms before you attempt to paint it. The study of folds and creases can be done in any drawing medium. It is important to indicate the direction and intensity of the light covering the subject.

Effects of light and volume on pillows drawn by Albrecht Dürer.

Oil and Volume

The study of the volume of drapery can be painted with a gradation of different lights and darks.

Once the lights and shadows have been roughed in, the initial drawing is shaded with a general application of color that will, more or less, represent the maximal luminous colors in the painting.

Then, using a somewhat darker tone, the medium tones should be painted in, whether or not darker colors are to be applied over them later.

The maximal contrast will be represented by those areas farthest from the light and

MORE INFORMATION
- Lighting **p. 12**
- Atmosphere **p. 20**
- Painting in oil **p. 78**

Leonardo and Gradating Lights

Leonardo da Vinci (1452–1519) drew continuous studies of everything he painted, especially when such an experience implied a certain amount of risk. Therefore, he carried out a careful study of light on drapery, a task that demanded a meticulous study of the lights on the creases of any material.

Leonardo da Vinci, Study of Drapery for a Seated Figure.

those representing an area of high luminosity. The line between these contrasts can either be a sudden divide in the two color areas, or be blended.

In this study of a creased cloth you can see how the light is further highlighted when it occurs on the side of an intense dark zone.

TECHNIQUE AND PRACTICE

PAINTING IN ACRYLIC

Acrylic resin dries very fast, leaving a semi-gloss and elastic surface
that may look similar to the texture of oil or the wash of watercolor.
The nature of acrylic provides the painter with a wide variety of ways of covering
the canvas, but there are a series of factors that must be taken into account
when working with this medium.

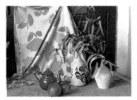

*The choice of a subject
with a frontal illumination
conditions the colors
of the painting.*

The Subject and the Beginning Composition

Due to the possible transparency of the medium, acrylic paint is very luminous. This characteristic makes it ideal for bright and lively motifs. The choice of subject and its framing must be established in accordance with the lighting. So, if you choose to illuminate the subject with frontal lighting, you will be able to see how the shadows of the still life's different elements are canceled out by the subject's actual colors. Therefore, the theme can be painted directly with lively colors, since the opacity of acrylic allows forms

*The initial theme is executed
directly with a brush and two
colors, one for the background
and another for the objects.*

to be changed during the painting process.

The Broad Stroke

Acrylic allows the painter to superimpose colors without creating transparent layers; it all depends on the density with which you paint. This quality allows the painter to apply a series of colors as an underpainting on top of which he or she can do the finished painting.

*The base colors are
painted with sweeping
strokes of flat color
that cover wide areas.*

The initial colors are applied in a general manner so that the underlying colors can "breathe through" the ones on top. Acrylic dries quickly, so there is no problem of the initial colors blending with subsequent applications, provided you give each color enough time to dry. If, on the other hand, you want to blend the base colors

together with new applications of paint, you will have to work quickly, retarding the drying time by spraying water over it.

Defining Forms

The forms are developed with a continuous superimposition of planes, a task that can be carried out in the style of a pointillist or value painting, blending colors and developing values, or if desired, applying the color directly onto the canvas.

These chromatic areas bring out the different elements of the painting in their totality. Each object is defined by the colors applied in the areas reserved for them, even though these areas are not entirely covered. Color serves the purpose of defining the object in order to recognize it; within the object's space there will be areas with no superimposed paint that allows the color of the background to come through.

*The forms are defined
by the use of local colors
that determine the space
without the need of
covering it entirely.*

MORE INFORMATION

• Different mediums **p. 28**
• The potential of acrylic **p. 74**

Superimposing Colors

Given the opacity of acrylic paints, colors be can superimposed without any difficulties. Therefore, the initial applications in an acrylic painting never impose a general color or tone, but only serve as a base for the successive coats, which define the forms by drawing and painting at the same time. Consequently, you can apply light tones over dark ones to develop both illuminated areas and shadows.

The first shapes can be applied over the underpainting with new layers of color.

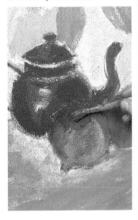

Color can be superimposed, both light over dark and vice versa.

Still Life, Flat Paint, and Pop Art

The paintings of Roy Lichtenstein are replete with satirical connotations. Nonetheless, this has not proved to be an obstacle for painting a still life in acrylic. His composition is simple: a circular scheme inside a square. The technique of painting flat colors in acrylic consists of carefully painting each one of the picture's areas, avoiding the adjacent parts.

Roy Lichtenstein,
Green Apple.

If the initial painting has been carried out with highly diluted paint, you can paint over it with denser layers in order to provide the painting with texture.

Flat Color

The possibility of painting large surfaces is one of the still life artists' favorite ways of resolving their works. The varying thicknesses of color can be used to cover the different areas of the picture in order to emphasize the planes.

On the other hand, the covering powers of acrylic paint allow the painter to construct the work in parts and then merge them into a whole.

Flat colors are easy to superimpose thanks to the covering powers of acrylic.

THE POTENTIAL OF ACRYLIC

For versatility of medium, transparent and opaque, smooth or textural,
acrylic is the most significant development for pictorial expression in the
last few decades. The still life, like any of the classic genres, has been perfectly
adapted to this most useful of all mediums.

Mediums and paints.

Different textures can be incorporated with the paint.

Acrylic Paint and Materials

Any non-oily material can be added to acrylic. This adhesive feature is especially handy when incorporating cardboard, plastic, and paper into the painting. These materials can be painted over after the first layer has dried. Still life compositions are a very suitable subject for super-imposing geometric materials on the painting.

One interesting experience is to paint a simple still life with thick applications of acrylic and attach various materials cut in the desired shapes over it.

Body and Transparency

The plastic potential of acrylic paint is limitless: you can obtain anything from the subtlest transparencies to the thickest layers.

Transparencies are obtained by adding more medium and/or water to the paint, although you must to bear in mind that, unlike watercolors, an acrylic glaze will vary the tone in a specific area and must be applied quickly so that the paint does not dry during the process.

Acrylic paint, on the other hand, is apt for applying thick layers over one another and for incorporating almost any ground material (ground marble, sand) with the color.

Masking

You can use masking tape to mask a specific area in the painting. With it you can also enclose those shapes that must contain thicker paint or that must stand out from the background.

In addition to masking tape, you can use various materials, including cardboard, for this purpose.

However, before masking anything, make sure that the underlying paint is dry, otherwise the paint will cling to the tape when removed.

Masking with masking tape allows you to paint objects while ensuring that the paint does not spread to other areas.

MORE INFORMATION

• Different mediums **p. 28**
• Painting in acrylic **p. 72**

When the masking tape is removed the area will have been shielded from the paint.

Once an area has been enclosed with tape or paper, you can paint over it, removing the tape after the paint has dried.

Washing with Wet Colors

One of the most interesting effects that can be obtained with acrylic paint is the color wash.

For instance, you can paint a specific shape in the still life with a lot of color over a dry area, and then with the brush blot up the paint in the areas that have to be illuminated. When the areas with the least color have dried (drying time can be accelerated with an electric heater), wash the painting; the water will remove the still-wet paint while the dry areas will remain.

Acrylic Glaze

The acrylic medium is very suitable for applying subtle glazes. The technique is very similar to that of watercolor: first you have to draw the theme, and then proceed with the first glazes that will provide the base for painting the following ones, always making sure that the applied glazes are dry before applying new ones.

Acrylic and Airbrush

Acrylic paint is especially useful for use with airbrush. In this painting, the hyper-realistic nature of the objects has been obtained by means of superimposed layers, several for each color and then more for each total gradation.

Acrylic can be applied in a completely transparent form.

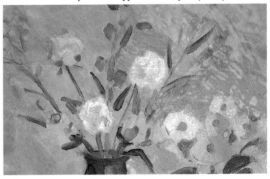

Paint the subject by spreading the paint toward the empty area.

The painted area is done in wash, after which the remaining wet areas can be blotted up.

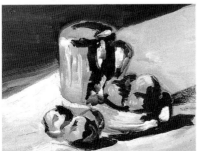

GLAZES AND OPACITIES

Every medium has specific properties that make it unique.
Thus, artists choose the medium according to the effects they want to obtain
in their painting. Although certain effects can be obtained by all mediums,
such as glazes and the superimposition of opaque layers, the method for
executing them varies with each medium.

Glazes with Watercolors

Watercolor is the most transparent of all mediums, to such a degree that it can produce a great variety of glazes and transparencies.

Transparencies with watercolors are always based on one particular color, which can either be the color of the paper itself, or a specific color applied by the artist. In any case, the artist has to bear in mind that this base color is going to be the most influential within the painting. Any glaze applied after this first one will tend to be darker.

Watercolor glazes are extremely subtle; any difference in tones will become clear only once the water has dried. Always remember to apply the glazes over dry areas so that the colors do not mix.

Glazes with Oil

Unlike watercolors, the most outstanding character of oils is opacity. However, the plastic characteristics of oils allow the artist to develop a variety of effects with color glazes.

Glazes in oil are used to alter slightly the tone of an area or to give the still life a predominant atmosphere through color that gives unity and coherence to the whole.

In order to paint a glaze, you make up a medium consisting of 50% turpentine and 50% walnut or linseed oil. Then add a small amount of color making sure that the mix maintains its

The oil glaze has a significant effect on the colors of the still life.

transparency. It is then applied over the surface of a completely dry paint.

Planes of Color

By alternating opacities with glazes, you can establish two definite planes: on the one hand, those planes nearest to the spectator, and on the other, all of the secondary planes.

The first planes will be painted in sharp tones, and the receding ones with glazes.

Glazes can also create a sensation of distance in the middle planes, producing a three-dimensional effect that provides depth to the painting.

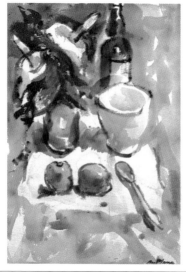

The application of dark colors next to light colors produces contrast; the glaze unifies the light areas of the picture.

Opacity and Texture

When you work with opaque paint, you should apply it in layers, bearing in mind that any gaps left in the top layer will allow the underlying colors to show through. This characteristic of opaque mediums allows the objects to acquire volume and to separate them from the background. If, in addition, the paint requires texture you should plan for this from the start by ensuring that the first layers are lighter than the final ones.

The volumes of the objects painted with opaque paint must be allowed to show through the various levels of

The background profiles the main element.

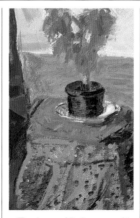

The shapes of the leaves provide detail on top of the underpainting while allowing the underlying colors to show through.

paint. Therefore, you first have to define the background, then paint the objects, and finally, work on the objects in the background.

Opaque Watercolor?

Watercolor can never be applied opaquely, but it can simulate opacity. In order to achieve opaque effects with watercolor, it is essential to draw the objects you want to paint in great detail.

Keeping selected areas free from paint is essential in this technique.

First some masking fluid is applied in selected areas of the still life; when this has dried, the area around it is painted. Once the paint has dried, the masking fluid is removed, leaving an undisturbed area of underpainting corresponding to the color of the paper.

Masking fluid is applied to protect the whites of the paper.

Once the paint is dry, the masking fluid is removed, leaving the pure surface of the paper.

Glaze and Opacity

Glaze has always been considered one of the most outstanding features of the oil medium. Over a color base, a transparent glaze of a lighter color is painted. This is how Willem Claesz enhanced the highlights of this glass.

*Willem Claesz,
Still Life (fragment).*

MORE INFORMATION

• A surface for oils, paper **p. 58**
• A transparent technique using two colors **p. 62**
• Painting in watercolor **p. 82**

PAINTING IN OIL

Each medium has its own best method of painting, depending on the opacity of the medium, the speed at which it dries, and its blending capacity. Oil possesses a great degree of flexibility in all three of these characteristics. Its opacity allows a continuous superimposition of layers and colors, it dries slowly, it can always be retouched, and its blending capacity facilitates the integration of forms within a still life. It is an ideal medium for our purposes.

Heavy over Thin

Painting in oil means that there is no need for chromatic superimposition. Thanks to the opacity of oil paints, a light color can be applied over a darker one without any trouble. What is important, however, is to ensure that the first layers of paint are thinner than the subsequent ones; in other words, the lower layers should contain more turpentine than the paint, while the subsequent layers will contain more oil than turpentine.

By respecting this order, you can paint a picture using two mediums, applying the underpainting with acrylic paint, which will dry fast in order to facilitate the final work in oil.

Painting with Turpentine

One of the best ways of beginning a still life is to apply the paint diluted with plenty of turpentine, which, due to its thin character, facilitates the subsequent layers of ever-increasing heavy applications. To paint with turpentine, the artist has to soak a clean brush in turpentine and then add a little paint and, in a clean part of the palette, press the brush down firmly in order to combine the turpentine and paint together into a uniform liquid.

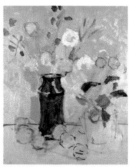

The underpainting containing abundant turpentine is used to rapidly paint the basic lines of the subject in color.

The Superimposed Painting

The superimposed painting begins with an initial application of color. After the basic lines of the subject have been drawn in, the initial paint is applied to fill in the forms, without yet defining the highlights or the chromatic relationship between the different objects.

The process of superimposing layers allows us to adjust the color and control the different effects of light in the painting.

When you are going to paint several layers of paint, it is important to remember that the first ones should contain more turpentine than the subsequent ones. In this way you will ensure that the final layer is always heavier than the previous ones.

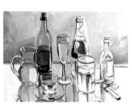

Painting with opaque layers allows the superimposition of planes.

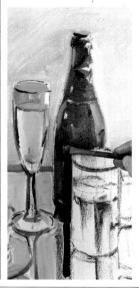

The Development of the Underpainting

The color is mixed on the palette and then the paint is applied to the canvas in order to cover the desired space.

You can fill in an area with small dots and dabs of color that combine to create the desired color, or you can simply cover the area with the mix of colors which, combined, result in the desired color.

The underpainting conforms to the structure of the painting.

The color is composed on the palette and becomes the underpainting once you have applied it on the canvas.

MORE INFORMATION

• Impastos in still lifes in oils **p. 60**
• Light and oils **p. 70**

Fast Drying

Oil dries through oxidation and not through evaporation as water-based paints and acrylic resins do. It is possible to speed up the drying time of oil using cobalt siccative, a chemical component that increases the oxygenation of the oil. Nonetheless, care should be taken not to apply too much, since this component tends to make the paint lose its luster and elasticity, which could lead to cracks on the surface of the painting once it has dried. In general, most brands of oil that are sold contain a small amount of siccative. Naturally, you can add some more, but do try it out before applying it to your painting.

Transparency or Opacity in the Underpainting

If the medium is sufficiently fluid, the underpainting will be translucent.

A translucent underpainting allows you to proceed with progressively richer tones, reserving the illuminated areas for the final stage as you progress.

When the first underpainting is opaque, the still life will have to be developed by superimposing planes of different colors. This initial underpainting creates a plane in the painting that all subsequent planes will have to relate to in order to achieve a balanced relationship.

Opaque underpainting helps to define planes in a painting.

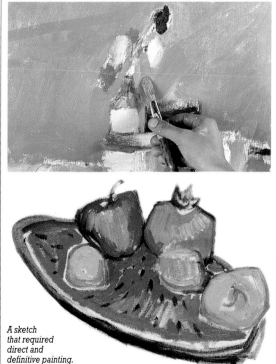

A sketch that required direct and definitive painting.

A GOOD INITIAL DRAWING

No matter what medium you choose, the underlying drawing must be executed
with care, since it is the structure on which the painting is based.
However, the medium can dictate the initial drawing: the underlying drawing
for watercolor, for example, is transparent and reveals the drawn structure
of the painting in detail. In most mediums it is necessary to employ opaque color
in order to cover any desired preliminary work.

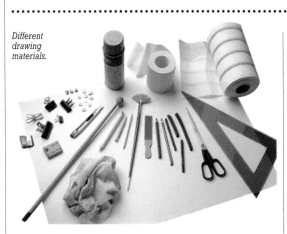

Different drawing materials.

The drawing as a guide for a painting.

Materials

There are one or two essential items required for sketching themes and detailed studies of the composition.

A few sheets of paper and a pencil are sufficient to make quick sketches; however, if you want to execute more detailed ones, it is recommended that you use papers of different sizes and qualities, pencils of two hardnesses, in this case, a 4B and an HB, a malleable eraser plus an ordinary one, a soft graphite stick, charcoal, a carbon pencil, sandpaper for filing down the tips, absorbent paper (a typical household roll will do), scissors, a ruler and tacks for attaching the paper to the surface of a drawing board.

The drawing as a medium in itself.

Alternatives to Drawing

You can draw using any medium. The purpose of your drawing may be simply to create a structure for painting the still life, or you can paint the whole painting using a drawing technique. In the latter, the brush is used just like a pencil to draw the entire picture. When you draw with dense mediums like oil, acrylic paint, or gouache, it is helpful to dilute the medium to the maximum without allowing it to drip, or load the brush with very little paint and apply it using the *frottage* technique.

The Drawing as a Guide or as Part of the Painting

The drawing can be used as a guide for applying coats of color over it, in which case an intricate drawing is not required, since all that needs to be indicated are the areas to be filled in with paint. The lines of this type of rough guide eventually disappear under the applications of opaque paint.

When using watercolor or other transparent techniques, a more detailed drawing may be required, particularly if the subject demands a greater

MORE INFORMATION

• Dimensions and proportions **p. 24**
• Framing and composing in practice **p. 32**
• Priorities. Drawing/painting **p. 90**

The drawing as a guide.

emphasis on the details of the individual elements in the composition. Here the drawing truly becomes a part of the painting and must be approached as such.

The lines of the drawing can be left visible to form part of the painting.

Drawing for a Fast Painting

Any motif is suitable for fast-painting a still life. The only important requirements are that you compose and frame it before hand, in order to obtain a solid structure from which you can rapidly put down the visual impact you wish to convey. The still life theme must be executed with clean, free strokes, slowing only at those details that help to establish the different planes of the forms. An emphatically clear result is essential in this type of work, since it is important to avoid ambiguities.

Pastel, Painting Through Drawing

Pastel, unlike other pictorial mediums, is a completely dry procedure. Although its binder maintains a certain amount of consistency, it tends to spread on contact with the paper. Thanks to this characteristic, it can be stumped, blended, in short, it can be manipulated in a variety of ways on the paper. Such an advantage is also a disadvantage in that it is unstable and can accidentally be smudged.

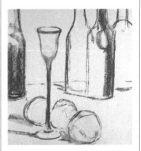

The pastel medium can be classified between drawing and painting.

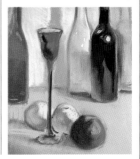

PAINTING IN WATERCOLOR

Watercolor is so transparent and subtle that color mixes not only play a role in the palette but also on the surface itself. This way, the color transferred from the palette will change if applied on top of a previous glaze.
The main characteristic of watercolor is its transparency, so the artist should always ensure that the initial luminous color prevails throughout the succeeding applications of darker colors. The underpainting process directs the painter toward the proper construction of the composition through the use of light.

A Definitive Approach

The successive layers of transparent watercolor will not hide errors underneath; if anything, the layers of tonality

The theme drawn in pencil should always be definitive before embarking on the painting.

will only emphasize those errors.

In the initial development of the theme, a correct drawing is essential. Therefore, one must take as much time in executing the drawing as is necessary in that no changes can be made once the painting has begun.

Superimposing Lights

In watercolor, the study of light is fundamental, both for developing the elements and for understanding the still life subject.

The successive layers of glaze increase the tones of the lower layers, so the initial applications of paint must be understood as those that control the final luminosity of the still life.

The initial applications of color establish the different luminosities of the overall painting. All superimposed layers are therefore darker planes of light, in which there may be openings through which additional luminosity shows through.

Light constructs the composition; this is an ever-present fact in watercolor painting that the artist must remember at all times.

Details in which two basic forms of superimposing light can be appreciated, one by means of color fusion on wet, and the other by alternating the work on dry and on wet.

The first watercolor layers always will show through.

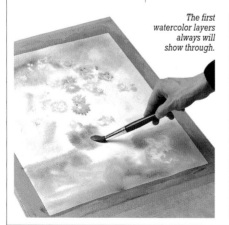

Before You Begin Painting

Sometimes when you paint on watercolor paper, rings from finger grease or pigment buildup will form at the edges of the wash that cannot be removed. It is a good idea to wash the paper with water and sponge before starting to paint.

Painting on Wet

When the surface is wetted in order to apply color with a brush, the painter must take into account that the paint will spread throughout much of the dampened area.

Normally painting on wet is done in order to cause forms to take on an unconventional character. For this an in-depth knowledge of the technique is required. When you paint on wet, the areas you wish to be left free of paint must be left dry. That is when reserving comes into play.

Paint on a wet surface becomes combined with the water on the paper itself.

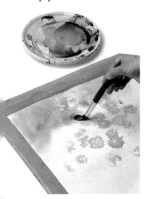

Drawing with the Tip of the Brush Handle

The artist can draw lines and carry out incisions over a previously painted and wet surface using the tip of the brush handle.

The lines will be more or less determined according to the thickness of the paint and the pressure with which the painter applies the handle. The pressure over the paper allows some paint to penetrate the paper so that if you apply a wash immediately afterward, the line will remain visible.

Creating lines with the tip of the handle over a wet surface.

Reserving Before Painting

Once the paint has been applied to the paper it cannot be removed. Therefore, it is best to set aside those areas that you want to remain white. This can be accomplished by covering those areas with wax or masking fluid, which will prevent the encroachment of paint from adjacent areas. The technique is called reserving and it is used in virtually all watercolor paintings.

MORE INFORMATION

• Watercolors. Colorism and value painting. Technical app. **p. 54**
• A transparent technique using two colors **p. 62**

Masking fluid is applied with a brush. Once it is dry, it will protect the areas it is covering from accepting paint from adjacent areas. It is later removed, leaving the paper untouched.

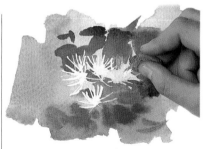

An untouched area achieved with white wax crayon.

TECHNIQUE AND PRACTICE

WATERCOLOR AND GOUACHE

Tempera is a mixture of pigment and glue or egg yolk bound together. It was first used to paint miniatures in medieval manuscripts, but nowadays few artists paint with this traditional medium; however, the use of gouache, a more developed form of tempera, which is thick and opaque and somewhat similar to acrylic, continues to be popular with artists. If you use both watercolor and gouache in a painting, a transparent base can be obtained over which totally opaque layers can be applied.

Wetting the paper.

Attaching the paper to stretcher sticks with staples or thumb tacks.

Attaching the corners.

A Resistant Surface

The variety of tones and transparencies that can be obtained with watercolor is unrivalled by any other technique; therefore, it is an excellent medium to be used in combination with gouache, by using it as a first transparent layer.

Gouache must be painted on heavy paper, a type that does not have a tendency to warp from the application of wet opaque paint.

Watercolor paper can be mounted on stretcher sticks. This is done by first wetting the paper, then stretching it over a frame, folding the corners down, and stapling the paper down around the outer edges. When the paper has dried it will be completely taut.

Transparent Work

This combined technique involves applying gouache over watercolor, provided it is always in this order, otherwise there would be little sense in doing it, unless you want to employ the watercolor as a glaze over the gouache, a somewhat delicate task because wet gouache turns soft again.

MORE INFORMATION

• Glazes and opacity **p. 76**
• Painting in watercolor **p. 82**
• The opaque medium **p. 86**

The first undercoats can be applied with transparent watercolor.

The underpainting can be applied with sweeping strokes across the surface, with the simple precaution of conserving the light tones in those areas that will remain free of paint.

Although there does exist a white color in gouache, reserved areas on the paper allow the different objects of the still life to have a unique quality in order to separate them from the painted areas.

Choice of Quality

The painter can choose from a number of different qualities of paints before deciding whether to paint with gouache or watercolor, or with both.

If you want to paint a picture with both watercolor and

The quality of the mediums employed will ensure that both glazes and opacities take on tones rich in color.

Compatibility of Wet Mediums

All pictorial mediums that share a common solvent are compatible, but it should always be remembered that mediums with a reversible solubility, such as gouache and watercolor, are always more stable when they are placed in direct contact with the paper. Plastic paints such as acrylics can then be applied over them.

gouache, it is wise to buy reliable brands in order to guarantee a stable chromaticism once the paint has dried, although there is no need to buy the most expensive brand unless it is absolutely necessary.

Slowing Down the Drying Time of Gouache

You may frequently find that the gouache dries before you are through painting a specific area, and you are therefore unable to maintain the same tone that you were working with. Therefore, in order to slow down the drying time it might be advisable to add a small amount of glycerine along with a bit more water.

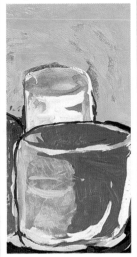

A few drops of glycerine on the gouache palette both slow down the drying time and provide the artist more time to develop the area being painted.

The Transparency of the Color

Due to its transparency and absence of opacity, watercolor does not require a white color because the white of the paper is used instead. This has to be taken into account when you are painting in watercolor; each color on the paper can be the basis for a subsequent color; so if you need to work in dark colors, they should be left to the end, since in transparent painting it is impossible to go from dark to light.

Gouache is opaque, but by alternating it with watercolor, the artist can introduce translucent areas within the composition.

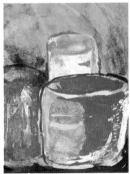

THE OPAQUE MEDIUM

Tempera, or gouache, is the opaque medium par excellence, despite the fact that it contains somewhat the same components as watercolor. Its differences are both in its application and in the result it produces. The solubility of gouache in water allows the painter to make changes at any stage of the work, subtracting or adding both colors and elements.

The Initial Scheme for an Opaque Painting

Thanks to its opaque characteristic, gouache paint allows the artist to paint light colors over dark ones. This means that your scheme can be drawn

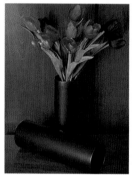

freely if you are going to paint a more expressionist still life. Naturally, it is equally important, as in the initial drawings for painting with other mediums, that you clearly define the

The initial drawing should clearly indicate the different areas.

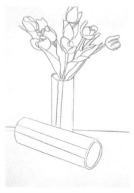

areas of the most important masses in the painting.

If, on the other hand, you take advantage of the flat paint characteristics of gouache and paint a picture containing flat areas of color, the initial drawing will have to be quite detailed, with lines clearly distinguishing the areas of light from those in shadow.

Mixing Color

Gouache can be used to paint totally uniform colors, therefore color mixes must be done with care before applying them to the paper in order to obtain a consistently flat area of color. The best type of palette for mixing gouache should be of plastic, glass, or porcelain, and contain somewhat deep pans for mixing the color in. To carry out a mix you should first leave a quantity of paint in a

The search for the definitive tone is achieved on the palette. First the areas of a chosen color are painted.

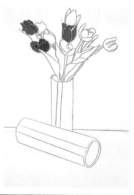

pan followed by another color in a different pan; then you load some of the color onto a brush and leave it in a third pan. Now

Painting in gouache is direct and definitive in the execution of the various planes of color.

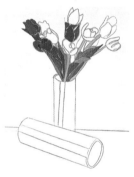

add part of the other color that is needed for the mix. Remember to always clean the brush before it comes into contact with a different color.

Painting Without an Underpainting

Underpainting is a progressive technique, that is, it consists of gradually superimposing layers used to approach the desired tones of the motif. With gouache you do not necessarily have to go through the process of underpainting, because it is a medium that can be painted directly.

This way of working results in completely flat color, which is the result of an exhaustive amount of color mixing on the

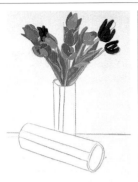

All colors can be painted flat by keeping within the limits of each area.

Tempera Wash

When mixing colors on the palette, you will notice that tempera (gouache) can be diluted down to the consistency of watercolor. The main binder of gouache is gum arabic; if you add water, the result is a significant reduction of the proportion of gum in the paint, which can change the nature and color of the medium.

palette. Two types of brushes are used: a soft, fine one for outlining and a wider one for filling in large surfaces.

Superimposing Opaque Planes

In the construction of a still life in gouache, the subject's different planes can be painted in two ways: you can paint one

The different areas of color can be gradually superimposed within the limits of the color of the adjacent chromatic area.

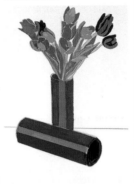

Each one of the areas in the background is developed in the same way as all other planes in the still life's internal construction.

MORE INFORMATION
• Alternative techniques. Tempera **p. 64**
• Glazes and opacities **p. 76**

plane after the previous one has dried, or, having carefully drawn the subject, you can paint all areas simultaneously taking care when painting with any color to reserve all other areas that will not be painted with this same color.

New, lighter colors can be applied on top of planes that have dried.

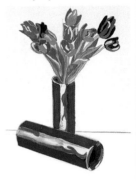

The still life is completed by outlining the lines separating each of the areas with a fine brush.

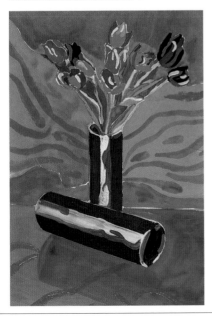

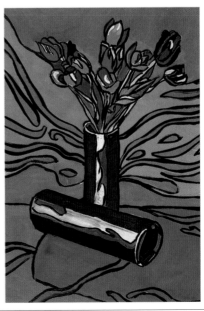

THE BACKGROUND AND THE MOTIF

One of the eternal problems in painting is the relationship between the background and the motif. When you paint a still life it is difficult to establish a relationship between the background and the objects in a way in which both planes come into a harmonious balance, even though there may be no incompatible elements among any of them.
In painting, the correct resolution of each of the forms is as important as their integration within the whole picture.

Differences Between the Subject and the Background

Here we refer to the *background* as the plane behind the main motif.

Frequently in still life paintings the background and the motif are so interlinked that it is difficult to see where one ends and the other begins.

The motif generally occupies the foreground, although sometimes when it takes up space in various successive planes, it will even become located in the background, following the rules

Frequently the motif blends with the background.

of perspective. The elements of the subject will always have to maintain their unity, whereas the background will be determined according to the position of all of the elements within the picture.

Relationships Between Motif and Background

The plane chosen for a still life will determine the general composition and framing, and of course its background. This key relationship is the most important aspect to be solved before beginning to paint.

Relationship by illumination. From the point of view of the development of tones, the motif of the still life possesses a number of tones that in the foreground vary according to the way the model is illuminated.

Relationship by atmosphere. The distance from the background of the still life can be

When you draw a still life scheme, the background should be separated from the foreground motif.

The integration of the motif with the background is carried out through the color of the shadows cast by the main objects.

established by means of a number of chromatic contrasts. A greater luminosity in the objects in the foreground and a

The union between the background and the subject is achieved by a relationship of illumination.

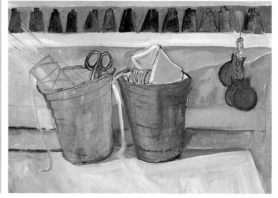

graying of the subsequent planes establishes a separation between both planes.

The Integration of the Subject and the Background

The objects of a still life may occur with any type of background and also have a relationship with it, but they should not appear to be glued to it.

When initially painting the canvas, there is an established permanent relationship between the colors of the objects of the still life and the colors that make up the background. Therefore, as the still life gradually takes shape, they blend together through the means of a chromatic relationship.

However, the atmospheric quality of the picture should be maintained, for instance, a still

The process of integrating the motif into the background. A color base on which to work is first chosen. This harmonizes the whole, the warm and cool colors of the different objects that have been added to the background.

Rembrandt, The Skinned Ox.

How Rembrandt Handled the Background and the Motif

Rembrandt (1606–1669) always obtained a balance between the form and the background, an aspect that creates a dynamism between both planes that is difficult to match. In his picture *The Skinned Ox*, the artist has strongly illuminated the figure, in such a way that the foreshortening of the animal invades the background through a gradual gradation both of the animal's warm chromaticism and the dark areas of the shadows, increasingly contrasting the smallest indications of light that finally outline the drawing.

life that contains a background of warm colors, will include these colors to some degree in the highlights and reflections of the objects represented.

Glazes, a Correct Solution

The glaze is one of the most effective ways of interpreting the atmosphere of a still life. By means of transparent layers of color the forms glow together through a subtly combined chromaticism. This can be accomplished with any wet medium, provided the background is completely dry.

The glaze is applied with plenty of medium and a small amount of paint in order to

make the paint very transparent. Dispersed elements can be brought together in one atmospheric space by the application of a unifying glaze.

Highlights Between Background and Subject

The highlights are those areas that receive the greatest amount of light. You should bear in mind what features may distract the spectator's attention away from the center of interest and divert them into

A tonal scheme of the different areas of light may be seen in the work of Lubin Baugin, The Wafer Biscuits.

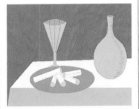

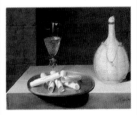

the background. This does not pose a problem when the background is neutral, but when it is treated with different hues, it is not easy to distinguish them from the planes of maximal luminosity. It is essential to highlight the most important elements in the still life. This can be carried out in one of two ways: by contrasting the dark areas that surround them or by accentuating these highlights with colors that are purer than the light areas of the background.

MORE INFORMATION

• Superimposing planes in a still life p. 26

TECHNIQUE AND PRACTICE

PRIORITIES. DRAWING OR PAINTING

The vast number of creative possibilities that the still life has to offer leaves the door open to all manner of drawing solutions. However, the studies of form and light are indispensable. The first entails a study of the line (drawing), the second an evaluation of tones in-depth. But for certain works you can substitute drawing for painting, if you proceed to develop the forms with colored brushwork.

The Construction

Drawing is the foundation of all plastic creation. In fact, it is difficult to think of any pictorial representation without solid drawing, whether it be developed at the beginning, or developed as the painting progresses.

There are two ways of approaching a drawing. It can consist of a balanced and measured construction, which would involve composition and traditional drawing; or, simply, by starting out with a general composition of masses, to which colors are later added.

Naturally, the drawing system used in either representation depends on what you want to represent; the first provides you with forms and masses, while the latter is freer, since the drawing of the still life will be carried out as the painting advances.

Marking out Masses

A linear drawing is a good way of starting a more detailed work, since the different areas and masses are clearly indicated.

First, the general forms of the still life are constructed according to general observation, and then a more complex process of synthesis that defines the sizes and proportions of the different objects is carried out.

The purpose of the drawing in this case is to indicate which area corresponds to which color mass in the composition. You will not require much more detail than this, unless you are going to paint with a transparent medium such as watercolor.

Form, Evaluation, and Color

When you begin a painting with an understanding of forms that does not rely on a grada-

The general setting out of the forms does not require any detail.

tion or an evaluation of tones, you can do without the initial scheme and instead use pure colors to construct the painting. By applying the paint directly, without an initial drawing, the forms of the objects are conceived through sweeping

A schematic drawing obtained through an in-depth geometric study is ideal for paintings that requires precision.

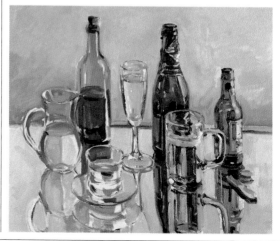

The Background and the Motif
Priorities. Drawing or Painting
Combined Techniques

91

Vincent van Gogh, Iris.

Van Gogh's Way of Modeling the Drawing

The paintings of Vincent Van Gogh (1853–1890) had the characteristics of drawings. The absence of a tonal flatness in the elements of his work and the short, almost drawn, strokes provides each plane with a unique gesture that permeates the entire space, thus modeling not only the motif but the surrounding atmosphere as well.

The areas of paint structure the shape of objects.

strokes, without carrying out a tonal development, but achieving a balance of the subject's different weights within the surrounding space by means of color masses.

The painting is constructed through large strokes.

MORE INFORMATION
• The initial painting and the form **p. 30**
• A quick technique **p. 36**
• Priorities. Drawing/painting **p. 90**

Drawing with Paint

Drawing is not only used to develop the structure of a still life. It is frequently present throughout the entire painting process. The paint can be applied in a very structured way as though the artist were drawing rather than painting.

The still life can be divided into planes when it is understood as a three-dimensional object or it can consist of a series of flat masses if it is to be painted like a flat drawing, establishing limits between different masses with a clean linear separation.

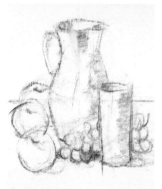

The drawing is completely constructed, each of the subject's volumes is represented. The picture should, therefore, have the same appearance as the drawing.

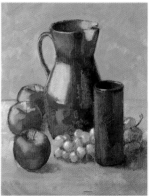

The still life has been painted over a detailed drawing; each mass of color is clearly defined.

COMBINED TECHNIQUES

A still life does not necessarily have to be represented using the classic mediums. By combining mediums and techniques, interesting plastic effects can be achieved that provide truly surprising results. When we speak of a painting executed with a combined technique, we mean that two or more mediums are employed within the same painting. In fact, one of the most typical mediums to combine with the more classic ones is the collage.

Materials

The basic materials required for creating a collage are pieces of paper and cardboard that are stuck on to a rigid surface, such as a mounted canvas or a board. In addition to the pieces of colored paper, you will need a pair of scissors, a knife, brushes, and glue. The papers we are going to use for this combined technique can be painted or they may have a

Painting paper with plastic paint.

color of their own. Whatever the case, it is always handy to have both types. Painted pieces of paper provide the painting with a pictorial character that contrasts with the completely flat color of the paper or cardboard. On the other hand, the paint provides the paper with a preparation that prevents it

Material used for a mixed technique to represent a still life.

from creasing when it is glued on to the surface.

The Approximation of Forms

Once you have chosen and composed your subject, you will have to decide what space each object of the still life will take up within the frame. In the resolution of a collage, it is essential to make notes to decide which areas should

The scheme of the still life consists of a drawing in charcoal.

superimpose others, what the background will look like, whether it will superimpose the objects, or vice versa.

The sketching of the forms onto the picture must be carried out carefully, in a completely linear way, caring more about the entire composition rather than the perfect definition of individual forms.

The Resolution of Open Planes

In a still life resolved with a collage, the artist must bear in mind that it is always easier to place a small element over a

The first shapes that are dealt with occupy a large part of the background.

large one rather than the contrary. Therefore, the background should be dealt with first, locating the large pieces of paper on the surface and estimating the area they are to occupy.

Before the paper is glued, it should be carefully cut out and then carefully refined with a razor.

Having applied the light background areas, the pieces that are used for the chairs and the floor are cut out and attached.

Having cut out the part that corresponds to the floor, it is then glued on.

Situating Superimposed Elements

Over the pieces you have been gluing on, other pieces corresponding to the medium-sized objects are cut out and stuck one on top of the others. If necessary, you can try out your design beforehand, without actually gluing. Once you have checked that it looks

You can rip some pieces of paper up with your fingers in order to create unusual forms.

fine, you can stick it onto the surface. Each area can be easily realized before it is glued, and in certain cases can be ripped out with your fingers in order to vary the "language" of the composition.

A still life's various planes, when superimposed, hide parts of what was glued on previously.

Small Details and Forms

When all the elements for the background are in place, you can begin on the objects of the still life. The collage should be understood as a continuous superimposition of objects from the largest to the smallest, on a value scale based on the position the forms occupy within the painting. Creating a still life with collage is similar to arranging objects in reality: first the tablecloth is laid; then the napkins and plates and, last, the fruit and other small objects.

The different planes are superimposed in a creative manner.

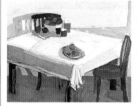

Paint is applied over the collage and the forms are outlined with a brush.

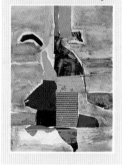
MORE INFORMATION
• Different mediums **p. 28**
• Watercolor and gouache **p. 84**

The small details are added in a logical order.

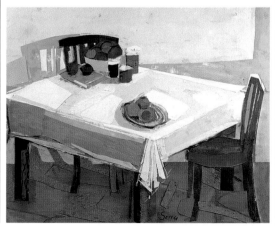

AN ABSTRACT COMPOSITION IN PRACTICE

Abstraction can be understood from many points of view, but you must always start out with an enthusiasm for synthesizing both form and color.
The still life is a particularly interesting theme for painting abstractly, because it has a series of characteristics that allow for a wide variety of experimentation in any pictorial medium.

The Appropriate Medium

You can paint an abstract still life using any pictorial medium. In fact, to abstract means to remove, to relocate, or to change. However, it is essential to understand the physical model you will be working from. Abstraction can be represented with watercolor due to its blending capacity over the wet surface of the paper, with oil due to its wide range of tonal values and the texture it provides, with acrylic due to its fast drying characteristics and its numerous plastic applications, and with pencil, the artist's most basic tool, due to its enormous versatility.

The still life, on the other hand, can be manipulated as the artist sees fit. In fact, the subject of the first abstract paintings were still lifes.

Synthesis

A still life can be represented abstractly using any of the facets that characterize the subject. The light, the volume, or simply the composition of the different planes can provide an abstract compositive theme.

A quick note of the most basic shapes of the still life helps to synthesize the forms to the maximum.

In order to synthesize the still life's different planes in an abstract form, it is essential to understand the elements of the subject correctly. The painting is usually constructed gradually, taking from the essence of the subject, and moving toward a conceptualization that will emphasize less the form and concentrate more on a coherent relationship between the elements.

Any medium can be employed in an abstract painting, but the execution of fast sketches, and the combination of watercolor and felt-tipped pens can always generate immediate ideas.

Real and Abstract References

There are many levels of abstraction, from the distorting of reality to pure non-objectivity. It is always best to base your painting on a real subject. This provides you with a logical guide for beginning the picture. Using a real model for reference allows for a large number of variations on a single idea. You can carry out a complete study of the model in all its different aspects.

A reference point does not necessarily require a real model, but working without one involves certain difficulties when it comes to the final painting, since the painter must do the final interpretation using a guide that does not actually exist in the real world,

Ramón de Jesus, The Heart and Its Bugs *(1996). Figurative references can be understood as symbolic questions within an abstract painting.*

Process of creating an abstract picture from a figurative model in six steps. Figures 1 to 4 are variations based on a study of the abstraction of highlights. Figures 5 and 6 are based on the object's volumes in the negative.

that is, it is not a copy of reality but rather a rearrangement of elements narrowed to their most basic forms in order to create a new language in art.

Painting or Drawing

It is best to develop an abstract painting with preliminary sketches because they help

artists to understand what they are trying to resolve: one sketch leads to another, thus creating an interesting combination of visual fragments that can be used in a completely original composition.

Working abstractly is dealing with the fundamentals that make up all forms in the visual world. Through free experimentation the artist can enter into an amazing world of visual excitement and creativity.

Balance and Construction

Abstract art is full of references to the still life, perhaps because it is the theme that best sets the problems of construction and balance between different objects in the subject. This is a wonderful pretext for painting an abstract still life, since the synthesis of the elements easily leads to an almost geometric interpretation, conforming to many of the ideas of abstract art, such as minimal expression of forms or the pure chromatic representation of objects.

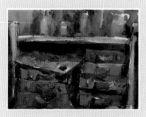

Manel Plana, Paint Boxes in the Studio. *Frequently the figurative painting contains typical abstract elements such as here, where construction and balance are inherent elements of the painting.*

An abstract still life can be interpreted as a drawing or a painting. Here the paint is based on color and composition.

Original title of the book in Spanish: *Bodegón*.
© Copyright Parramón Ediciones, S.A. 1996—World Rights.
Published by Parramón Ediciones, S.A., Barcelona, Spain.
Author: Parramón's Editorial Team
Illustrators: Parramón's Editorial Team

All inquiries should be addressed to:
Barron's Educational Series, Inc.
250 Wireless Boulevard
Hauppauge, NY 11788

International Standard Book No. 0-8120-6618-9

Library of Congress Catalog Card No. 96-85335

Printed in Spain
98765432

Note: The titles that appear at the top of the odd-numbered
pages correspond to:

The last chapter
The current chapter
The following chapter